Stencil Pirates

A Global Study of the Street Stencil

JOSH MACPHEE

Soft Skull Press Brooklyn

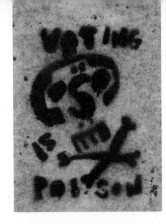

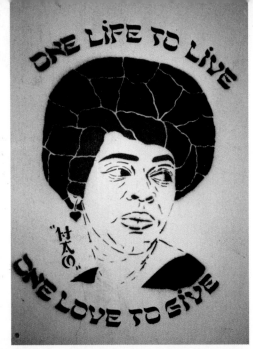

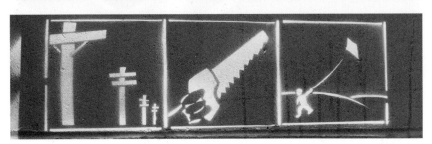

(002)
★

All Writing, Layout, & Design: Josh MacPhee
Photo Credits: See page 196

Published by Soft Skull Press, 55 Washington Street, Brooklyn, NY 11201

Distributed by Publishers Group West, 1.800.788.3123, www.pgw.com

Printed in Hong Kong

ISBN: 1-932360-15-8

Library of Congress Cataloging-in-Publication data for this book is available from the Library of Congress.

www.softskull.com
www.stencilpirates.org
www.justseeds.org

Fourth Printing, October 2005

1. Cut along dotted line 2. Cut out black sections 3. Hold against flat surface 4. Spray paint through cut stencil

Stencil Pirates

Top row: Heart Attack by MEEK, Melbourne; Street Scene by Epsylon Point, Paris. Second row: All City Assholes, Milwaukee; Mermaid by Lord Hao, Paris; Organic Gardening for the Revolution by Shaun S., Nashville; "Evildoers of the World Unite!", Barcelona.
Page 2, clockwise from top left: Voting is Poison by Ryan, Bloomington IN; Dairy is Fucked, San Francisco; One Life to Live by Lord Hao, Paris; Kite Flying Triptych, Bloomington IN; Shrouded Figures by PSALM, Melbourne; Giraffes by PRISM, Melbourne.
Page 6: Don't Be Scared It's Only Street Art by DLUX, Melbourne.

This book is dedicated to my family and to Dara, for always being there and helping me make it to the end.

Thanks to all the stencilers, graffiti writers, anarchists, and troublemakers that were part of this, you know who you are. Thanks to everyone that contributed photos, advice, helped with the Stencil Pirates Art Show, and inspired me. Never stop painting.

Special Thanks to the Daves (Grant, Jacobs & Merritt) for unmatched technical support, to Kevin Coval, Liz Goss, Dara Grenwald and Sarah from Soft Skull for proofing and editing the text, to Jamie Schweser for all the book advice and help, and to everyone at Soft Skull, Clamor and Boxcar Books, y'all are great!

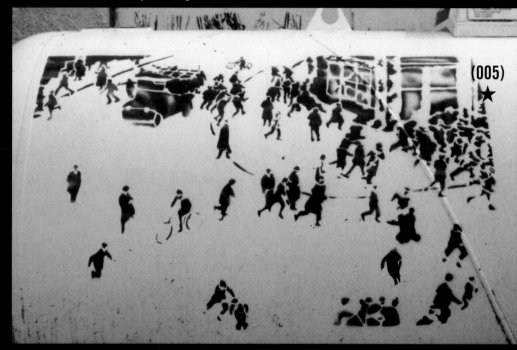

(005) ★

DON'T BE
SCARED
IT'S ONLY
STREET ART

(006)
★

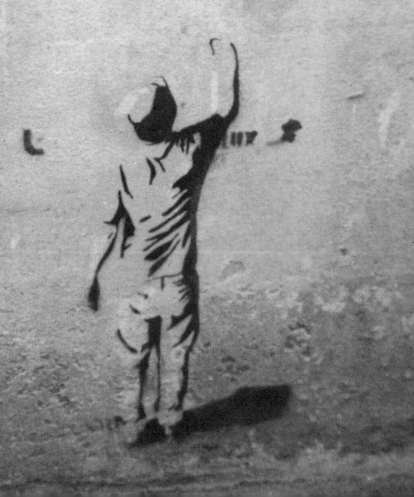

CONTENTS

It was 1990 and the first Gulf War was beginning. I was stuck in high school and desperately looking for information to explain what was going on around me. While anarchist and other leftist political writings were appealing, it was the graphic format of the radical political comic *World War 3 Illustrated* that really opened a new world to me. *WW3* artists Anton van Dalen, Seth Tobocman, and Peter Kuper were using stencils to create powerful graphics in comics and on the street. They used the bold graphic quality of stencils to both express their feelings about politics and in an attempt to explain the war going on around them.

Growing up in a small town in Massachusetts, no stencils were painted on the streets around me. Some friends were attracted to traditional graffiti, and I tried my hand at that for a couple months, but I was always more interested in the stencil and its overt political usage. It was a couple years later on road trips to see punk shows at ABC No Rio, in New York's Lower East Side, that I got to see real street stencils. The Lower East Side was a cradle for all kinds of radical political cultural activity, and a birthing ground for street stenciling, but I'll get to that later.

I painted my first stencils on the street in 1992, the night after the LA policemen were acquitted of the Rodney King beating. The stencil was a small, about 11"x17", but somewhat ambitious three color job: a U.S. flag that had a swastika instead of stars and "Justice?" written along one of the stripes. A short while later I heard that some people had missed my point and thought a neo-nazi had painted it! I learned a couple important lessons; first, that symbols are extremely

PREFACE

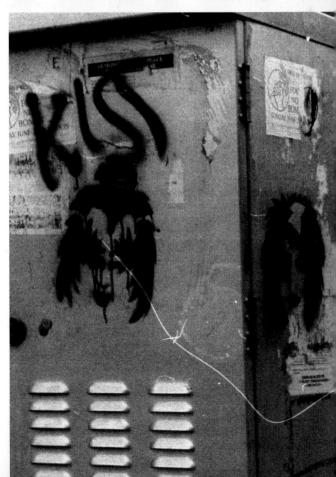

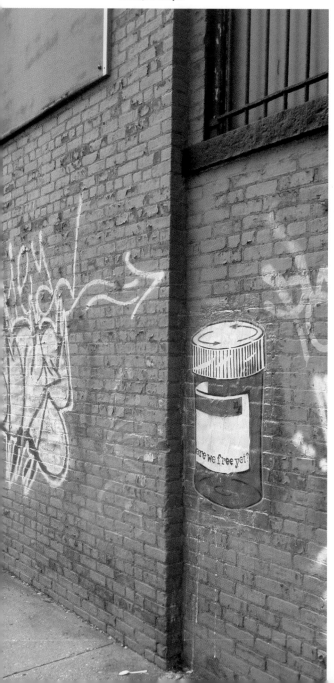

Page 8: KISS by Josh MacPhee and Brad Sigal (circa 1993), Washington DC.
Page 9: Are We Free Yet? by Josh MacPhee (circa 2003), Brooklyn.

powerful and I need to consider how they will be perceived before I can control their meaning, and second, that I should run messages by some people before painting them all over town because they could easily be misinterpreted.

My next attempt was more subtle, more effective, and this time I was removing swastikas instead of misusing them. I was living in Washington, DC in 1993 and someone was painting nazi graffiti all over the city, mostly swastikas and SS lightning bolts. My friend Brad and I were getting extremely pissed as it spread across the city and feared that it represented a growing racist movement. We wanted to get rid of it (this, of course, was the one time the city failed to remove graffiti) but knew that if we covered it with straight paint, it would simply provide a fresh canvas for more nazi graffiti. It dawned on us that the SS bolts looked exactly like the letter "s" in the band *KISS*' logo, so we decided that we would change all the SS bolts to say *KISS* and stencil the band's faces over the swastikas. This way we could cover the nazi garbage and at the same time create something so absurd that the nazi vandals wouldn't know what to do! After a couple nights of work the town was covered with *KISS* and soon after the nazi graffiti stopped altogether.

Ever since my first attempts, stencils have become part of my everyday life. I can't stop cutting, painting, and photographing them. They opened up a world of public expression to me, and I want to share that with everyone that's ever felt like they had no control over their environment. There is no way to document all of the hundreds of thousands of stencils being painted on the street, but for this book I've tried to capture the depth and breadth of the art form. Enjoy!

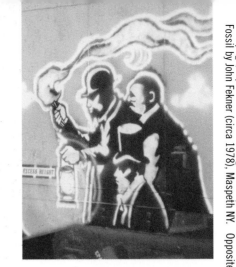

(010)
★

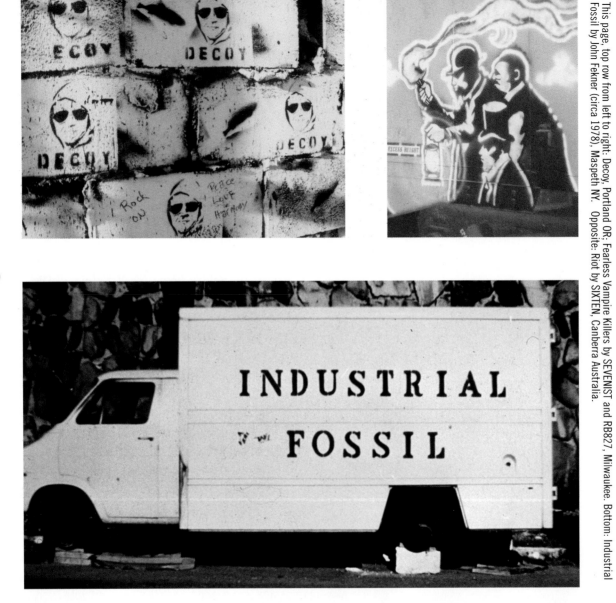

THE PORTABLE F

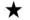

Stencils are the cheapest and easiest way to print an image over and over again on paper, a sidewalk, a dumpster, practically anywhere. Artist Anton van Dalen calls them "a portable printing press."[1] Unlike silkscreen and other printmaking techniques, stenciling is simple and inexpensive. All you need is a piece of cardstock, an exacto knife, and a can of spray paint. In a single night, a stenciler can print hundreds of images with nothing more than these simple tools.

Street stencils exist somewhere between official street signage and traditional graffiti (tags, throw-ups, pieces). They tend to use simple words and basic images that can be easily read by the general public. These images and/or text are repeatedly printed over and over, and oftentimes replicate official signage, mocking city markings on lampposts and electrical switch boxes. At the same time, stencils are graffiti; they are illegal and alter public and private property. They are an artist's ideas and stories projected onto the city. Whether it is a radical political message, an arresting graphic, or simply a stray word painted throughout a neighborhood, stencils claim billboards, walls, and sidewalks as the canvas of artists and/or activists.

RINTING PRESS

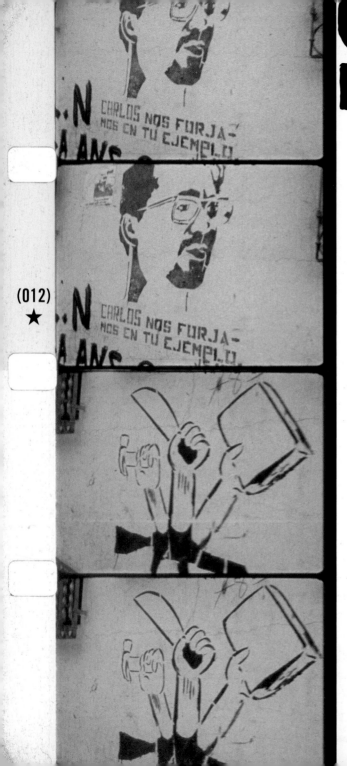

SPARKS

The term "stencil" comes from the French *estenceler* meaning to decorate with bright colors, which in turn is derived from the Latin *scintilla*, which means "a spark."[2] Stenciling is one of the oldest forms of printmaking. It was commonly used in Egypt during the time of the pyramids and in China when the Great Wall was built. The Japanese learned the craft from the Chinese and developed it into an extremely precise art form for fabric printing.[3] Indigenous people throughout North and South America used stencils, and decorative stencil designs can be found on Roman, Greek, Etruscan, and Buddhist artifacts that are all thousands of years old. After the Russian Revolution, Ivan Maliutin created at least a dozen political posters in the early 1920s for the Soviet political education department using stencils and guache.[4] At the same time, Vladimir Mayakovsky was producing similar stenciled posters for ROSTA, the Soviet telegraph agency. The bold and simplified texts and images were stenciled as posters and used to bring news to a population that was largely illiterate.[5] There are scattered bits of evidence of stencils showing up throughout ancient and modern history, from stencils of Charlemagne's signiture, to European political parties in the 1940s and 50s using stencils to mark their territory. For the duration of this time, the basic printmaking technique has stayed the same. An open design is cut out of a solid, impervious material, that material is held flat against the surface one wishes to paint, then ink or paint is pushed through the design, originally by brushing or dapping, now usually with spray paint.[6]

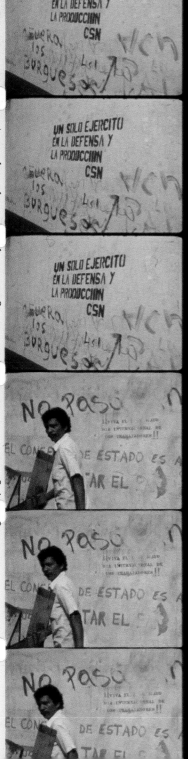

The full history of stenciling is extremely interesting, but I want to focus on the modern evolution of the street stencil. Tristan Manco's *Stencil Graffiti* does a good job of tracing the history of much of the modern European stencil movement to Parisian artists like Blek le Rat, who began stenciling around 1982.[7] Even earlier than this, there was an explosion of stencil usage in New York, Baltimore, Mexico, Nicaragua, South Africa, England, and on the Berlin Wall. There is no clean and simple narrative history of how exactly stencils jumped off city-painted street signs and ornately decorated furniture onto walls in the form of rebellious slogans and magical images. Instead there is a complex web of evolution that connects and disconnects along the way.

In Nicaragua, the stencil became popular in the 1970s as part of the campaign by Sandinista revolutionaries against the Somoza dictatorship. The Sandinistas had taken their name from Nicaragua's most recognized anti-colonial hero, Augusto Sandino. Sandino often wore a giant cowboy hat, and the Sandinistas and other anti-Somoza activists started using stylized images of Sandino, or simply his hat, as symbols of resistance. By the time the Sandinistas overthrew Somoza, thousands of images of Sandino had been stenciled all over Nicaragua. These stencils sat on the walls next to revolutionary posters, slogans, and poems painted in freehand by workers and revolutionaries as they learned to read and write. It was the ability of the stencil to be repeated endlessly that gave it extreme power, in this case to represent Nicaraguan resistance. After the initial success of the revolution, the stencil continued to be used. Repetitive stenciled images of "martyrs" reminded people of what was lost during the struggle and neighborhood political organizations used stencils to clearly mark the areas they operated in.[8]

(013)
★

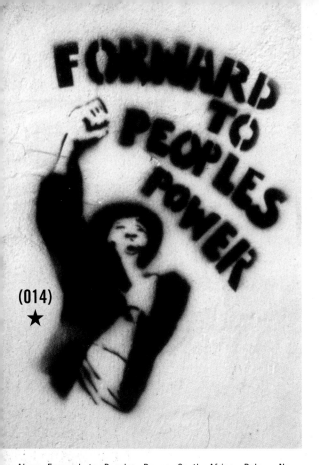

(014)
★

Above: Forward to Peoples Power, South Africa. Below: No Compromise, South Africa
Opposite, top: Faces, Berlin Wall; bottom: Spring 1951 by John Fekner (circa 1977), Woodside NY.

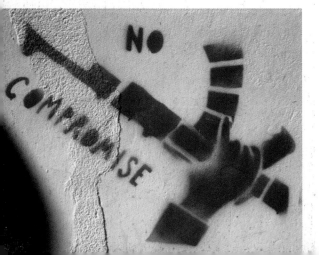

At the same time, halfway around the world, graffiti was quickly becoming a way for the resistance movement to communicate in South Africa. As censorship of the press increased in the 1970s and 80s, the anti-apartheid movement turned to the walls as a place to communicate the news of the day. Stencils were a large part of this. Particularly in cities, revolutionaries stenciled thousands of messages, the most common being "Free Mandela." Other images included resistance fighters with weapons, calls for "Peoples' Power," and humorous statements attacking then Prime Minister P.W. Botha such as "P.W., the sky is falling on your head." In South Africa under apartheid, a street artist could easily receive two years in jail for a first offense.[9]

Simultaneously in Mexico, the street stencil took on a different form in the hands of the artist collective Group Suma. Suma was formed in 1976 and quickly began using stencils to paint on the streets. The group was part of a movement of radical Mexican art collectives that were trying to leave the art world and gallery system and reach a much wider section of Mexican society. Experimenting with various art forms, Suma found that by repeating stenciled images representing different sections of Mexican society, they could easily create large murals dealing with important social issues. These murals appealed to, and could be understood by, extremely wide and diverse audiences. Life size stencils of anonymous bureaucrats and poor indigenous women were used to expose and confront the relationships between those in power and the hardships of daily life for everyone else. The collective was also interested in making the artistic process open and available to everyone. By creating murals with the basic tool of the stencil, which was familiar and popularly used on street signage and in political campaign signage, they made the creation of the art more accessible to people.[10]

Around this same time, street stenciling was becoming a popular form of expression in Europe. Blek le Rat began stenciling lifesize humna figures around Paris in the early 80s, inspiring a whole group of young artists. In 1978 and 1979, the British punk band

Crass began stenciling its logo and anti-militarist slogans on record covers, protest banners, and city walls.[11] In 1976, the fourth generation of the Berlin wall was built.[12] Sturdier than earlier versions, it was now a solid concrete wall, waterproofed and painted white. Soon after being completed it became a canvas for artists and activists on the western side, and it wasn't long before stencils began to materialize between all of the other graffiti. The wall was simultaneously a highly politically charged barrier and a 40-mile long gallery for artists' expression. Millions of people came to see the wall during the 1980s and the art and expression on it spread across the globe with stories told and photos taken.[13]

New York City appears to be the place where street stenciling really took off in the U.S. New York City in the 1970s saw an explosion of art on the street. Groups like the Madam Binh Graphics Collective were moving Leftist politics from Communist newspapers and political rallies onto everyday streets by spray painting slogans and pasting up posters.[14] Graffiti writers moved from simple tags in their neighborhoods to spray-painting top to bottom productions on trains that traveled throughout the city. The blending of political street art, graffiti entering into popular consciousness, and formally trained artists being inspired by graffiti to bring their art out of the gallery is what set the stage for street stenciling. Graffiti was exploding in NYC, articles were being written about it in the Village Voice and artists like Keith Haring and Jean-Michel Basquiet were popularizing it in the art world.[15] Early New York stencil artists Anton van Dalen, John Fekner, and Seth Tobocman all cite traditional graffiti as one of the motivations for beginning to stencil on the street.[16] At the same time, big clubs like the Danceteria had artists paint the walls. Since the walls would get trashed during a busy night, artists started stenciling them since the art could then be easily reproduced. Fekner, as well as large numbers of other artists, painted the walls at the Danceteria. In the early 1980s, artists were stenciling on clothes. Kat P. Sent was spray-painting peace and

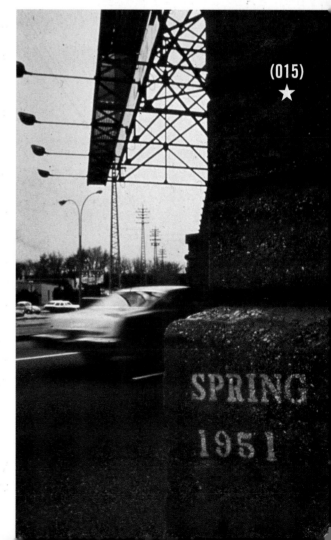

(015)
★

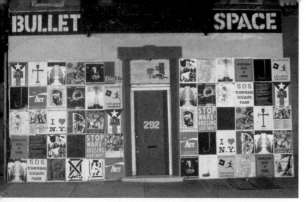

Above: Poster and stencil covered front of Bullet Space (circa 1984), New York City. Below: Anton van Dalen painting a stencil against the second Gulf War (2003), New York City.
Page 19: Wheels Over Indian Trails by John Fekner (circa 1979), Long Island City NY.

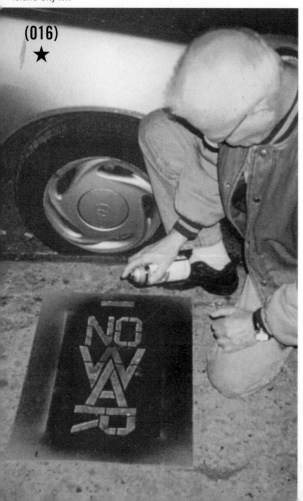

(016)
★

anti-Reagan t-shirts.[17] Seth Tobocman says, "Basically the whole time period was about breaking down barriers. Politics, art, and music were all mixing together. Trained artists were getting into graffiti and politics, activists were starting to mark the streets and be involved in bands, punks were getting into art and politics. Everything was mixing up and it was all happening in the street."[18]

Out of this brew came a large number of artists who experimented with stenciling on the street. David Wojnarowicz started stenciling around the city in 1979, particularly on the outside of galleries and other art world spots in an attempt to shake up their conception of what art was.[19] Eric Drooker, Michael Roman, and James Romberger, three more artists affiliated with *World War 3 Illustrated*, also tried their hands at stenciling in the late 70s, early 80s.[20] A similar scene began to develop in Baltimore at the same time, with dozens of artists using stencils to communicate with each other in the street. The stencils of many of the Baltimore artists where extremely self-aware of their audience. John Elsberry's "Blind Man's Bluff" was a stencil of the title in Braille letters, which is of course unreadable to both the audience who can see it and the audinece that would normally read Braille. Ruth Turner's "Foxtrot" series were colorful feet stenciled onto the sidewalk in dance diagrams, almost demanding a passerby to try out the dance.[21]

Two of the earliest artists that really explored the boundaries of the stencil medium and attempted to maximize what they could do with it were John Fekner and Anton van Dalen. I will talk more about them because they are good examples of how artists transitioned to stenciling on the street.

Van Dalen was born in Holland in the 1930s when stenciling was still a respected craft art. Growing up, stenciling was part of the culture around him, something he knew about, but it wasn't part of his art practice. He moved to New York in the 1960s, and his Lower East Side neighborhood became the subject matter for most of his drawings and other art. In the late 70s he began feeling like

STENCIL PIRATES TEMPLATE B: ANTON VAN DALEN

1. Cut along dotted line 2. Cut out black sections 3. Hold against flat surface 4. Spray paint through cut stencil

his art was too separated from its subject matter. In 1980 he began to transform some of the images about the neighborhood into stencils and paint them on the street. This was a way to give the work back to the neighborhood and create a direct feedback loop. The content of the work was the street, so what better place for its context than the street? Van Dalen doesn't recall knowing anyone else at the time stenciling in the Lower East Side, but he cites traditional graffiti and the Mudd Club as early influences to moving his art to the street.[22] The Mudd Club, a hot spot and gathering place for young hipsters and up and coming artists like Basquiat and Blondie,[23] would do very basic text stencils around the neighborhood to announce upcoming shows. Although van Dalen was meticulous in the design and execution of his stencils, he's said that he did not see this early stenciling as part of his art practice and instead thought of it as ephemeral and as such didn't document it. The act of painting on the street and the neighborhood's reaction were far more important than the specific stencil print itself.

John Fekner came to stenciling through a conceptual art background. Although he has flirted with high profile gallery shows and representation, he has consistently been committed to creating work that reaches a broader and more diverse audience. In 1976, he began stenciling random dates on sites around Queens. He was using store bought ready-made letters and numbers. Fekner cites Richard Artswchager's "blps" as a main inspiration. These "blps" were stenciled punctuation points, sort of like odd shaped commas that Artschwager would paint throughout the city. Fekner began working with words and leaving short descriptive statements in non-art places, primarily industrial zones. He would paint the word "decay" on a crumbling factory or "industrial fossil" on an abandoned and rusting delivery truck. He saw his audience as the public at large, and primarily industrial workers who worked in the sites he painted. He moved from small phrases to stenciling statements on highway onramps and high up on buildings. Out of necessity these stencils became larger and larger and he began cutting the giant letters out of abandoned refrigerator boxes and other found cardboard. Fekner's stencils drew attention to what was painfully obvious yet seemingly ignored: the collapse and abandonment of poor and industrial areas of New York City, particularly his home, Queens.[24] Art historian Lucy Lippard has called Fekner "a caption writer to the urban environment, adman for the opposition."[25]

From this complex net of beginnings twenty to thirty years ago, stenciling has become a hugely popular global art form. Each early strain has influenced the art in its own way. The ideas and aesthetics within the decorative, political, conceptual, and graffiti-based origin points are all still present today.

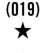

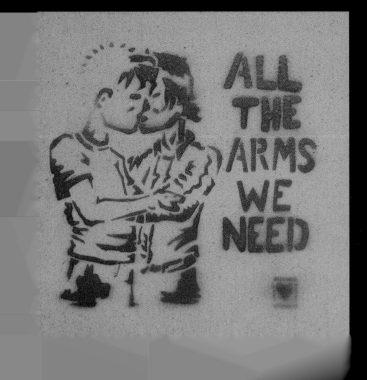

STREET

As you read this, somewhere across the globe someone is painting a stencil on the street. Some of these painters are artists, some are activists, some are simply doing their job, marking dumpsters or plywood sheets. For the sake of organizing this book, I've broken modern street stenciling into different types, or styles. A sharp eye should be able to find these four main types: (1) utilitarian (industrial/decorative), (2) anonymous, often cryptic, message or image, (3) political, and (4) the traditional graffiti usage of ego markings. These types are in no way mutually exclusive. They definitely overlap, but these categories are useful when trying to look at how stencils operate in public space.

STYLES

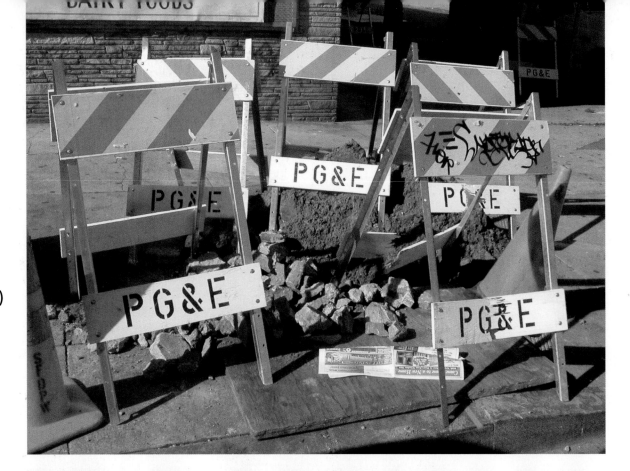

IT'S OFFICIAL

The reasons stencils are used for industrial and decorative purposes are largely the same reasons artists use them. They create a clean, crisp image, are infinitely reproducible in a uniform manner, and can be painted onto just about anything. A thousand trashcans can be easily marked with the exact same logo and a thousand kitchen chairs can be painted with the same country duck motif. In many countries, street signs and traffic markings are stenciled. These industrial stencils boil down the intended meaning of any marking into the most basic graphic and textual elements.

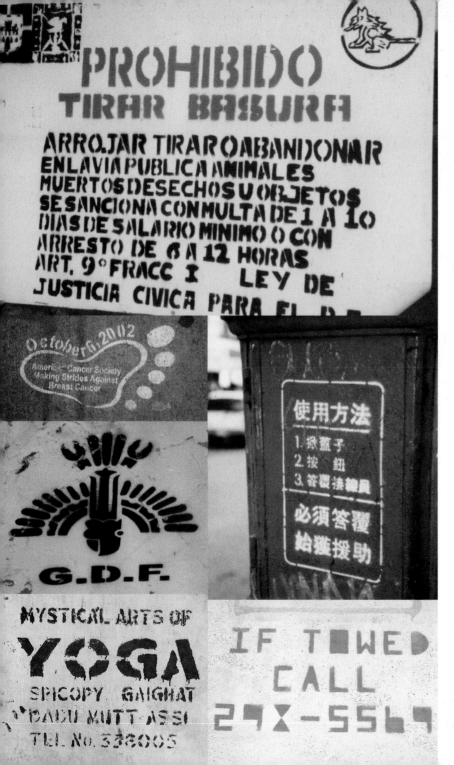

Although I'm much less interested in this kind of stenciling than the other types, there are actually a large number of examples of impressive industrial stencils. This directness of industrial stenciling has definitely influenced artists. According to Anton van Dalen, he wanted his stencils "to operate like traffic signs, you absorb the meaning before you even know it."[26] Often, artists can use this directness as a starting point for mocking authority, generating satire, or just creating mischief by altering official signage. One of the most common official stencils is "Post No Bills," which is completely ubiquitous in many major cities. Artists have lampooned this simple statement over and over, changing it to "Post Mo Bills" or "Pray for Pills." Skateboarders have also been changing

cont. on page 27

cont. on page 27

(023)
★

Clockwise from top: "Dumping Garbage Prohibited," Mexico City; Chinatown Electrical Box, New York City; If Towed Call, Nashville; Mystical Arts of Yoga, Varanasi India; G.D.F., Mexico City; Breast Cancer Run, Boston.
Opposite: Electrical Company Sawhorses, San Francisco.

POST NO BILLS

POST-NO BILLS

POST NO BIL

POST NO BILLS

POST NO BILLS SF MUNI CODE 709

POST NO BILLS

POST-NO BILLS

NO ANUNCIAR

(024)
★

ST NO BILLS

POST NO BILLS

NO ANUNCIAR

POST NO BILLS

POST NO BILLS

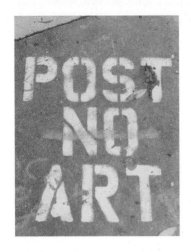

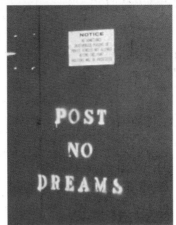

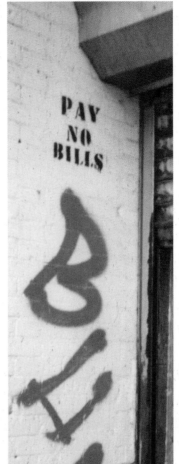

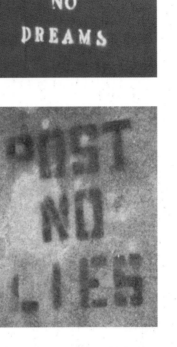

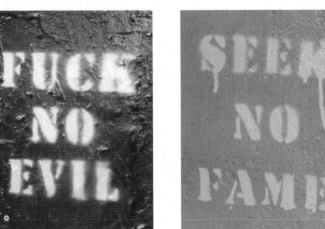

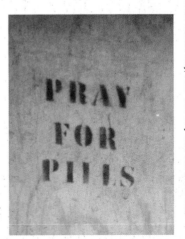

Top row: Post No Art, San Francisco; Post No Dreams by Fohn Fekner, New York City; Pay No Bills, New York City. Second row: Just No Idea, New York City; Post No Lies, San Francisco. Third row: Fuck No Evil, New York City; Seek No Fame, New York City; Pray For Pills, New York City. Opposite page: Post No Bills stencils from Mexico City, New York City and San Francisco.

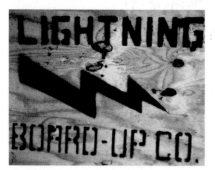

LIGHTNING BOARD-UP CO.

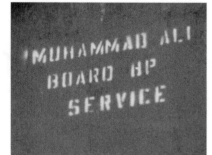

MUHAMMAD ALI BOARD UP SERVICE

ANCHOR 1-800

HEARTLAND BOARD-UP

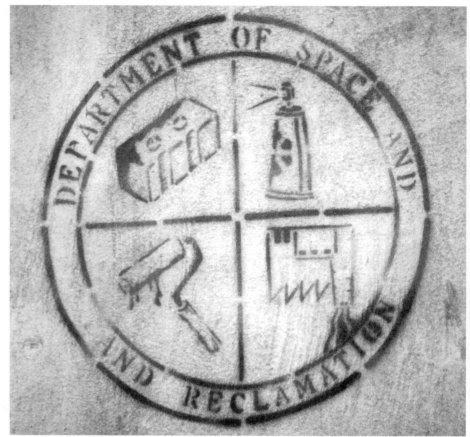

DEPARTMENT OF SPACE AND RECLAMATION

BUZY BEE BOARD-UP 773 622-9700

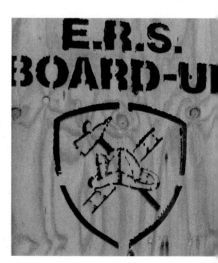

E.R.S. BOARD-UP

official city anti-skateboard signage for years with stencils, or simply creating their own official looking stencils that encourage skateboarding (see page 186). British stencil artist Banksy used the signifiers of the official stencil to create a logo for a fake streets and sanitation agency that designated walls as "Official Graffiti Areas." In Chicago, the art event/group The Department of Space and Land Reclamation stenciled dozens of official looking logos around the city. These were to advertise for a specific event, but also to announce the presence of this new "city department." Their "official" look has camouflaged the stencils, and years later some still remain, and this is in a city that removes most graffiti within 24—48 hours.

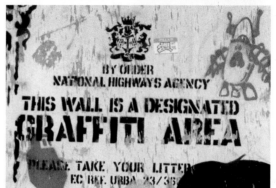

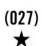

(027)

★

This page, top row: Use Trash Can, Perth Australia; Trash Picker by ANT, Vienna Austria. Bottom: This Wall is a Designated Graffiti Area by BANKSY, London.
Opposite page, clockwise from top left: Lightning Board-Up, Chicago; Department of Space and Land Reclamation by Counter Productive Industries, Chicago; E.R.S. Board-Up, Chicago; Buzy Bee Board-Up, Chicago; Heartland Board-Up, Chicago; Anchor Board-Up, Chicago; Mohammad Ali Board-Up, Chicago.

(028)
★

Clockwise from top: Decorative Anchors, New York City; Floral Cross, New York City; Truck Door Pattern, San Francisco; Decorative Shapes, San Francisco; Lotus Flower, San Francisco; Three Swirls, New York City; Decorative Circle, New York City.

The main element in most industrial stencils is typography. Letterforms are both extremely important and extremely undervalued in stenciling. Stencil type is an historic art form and has its own origins and history. I split modern stenciling type into two main categories: "tech styles," named for the use of technology in their creation, and "hand styles," letter forms drawn and cut by hand. Tech styles have their root in the standardized and mass-produced stencil letters found at hardware and craft stores. Available in a limited variety of sizes and styles, they made it easy for artists to create basic statements or mimic official public or private signage, which had often been made with the same prefab letters. The entrance in the late 1980s and early 90s of home computers with stencil fonts like "AG Book Stencil" and "Housebroken" allowed artists to create official looking type even easier. Now artists are using an ever expanding font catalog to turn just about any type style into stencil lettering. The website www.stencilrevolution.com even has twenty stencil fonts you can download for free. Hand styles are interesting because, like a signature, every artist's style is different. Some artists choose to fill in their A's and O's, others develop intricate systems of bridges to hold the letters together.

(031)
★

From the top: Object, New York City; Grace, San Francisco; Finish, New York City; Bullshit, San Francisco; Tough, Chicago; Cheat, Pittsburgh; Euphemisms, San Francisco.

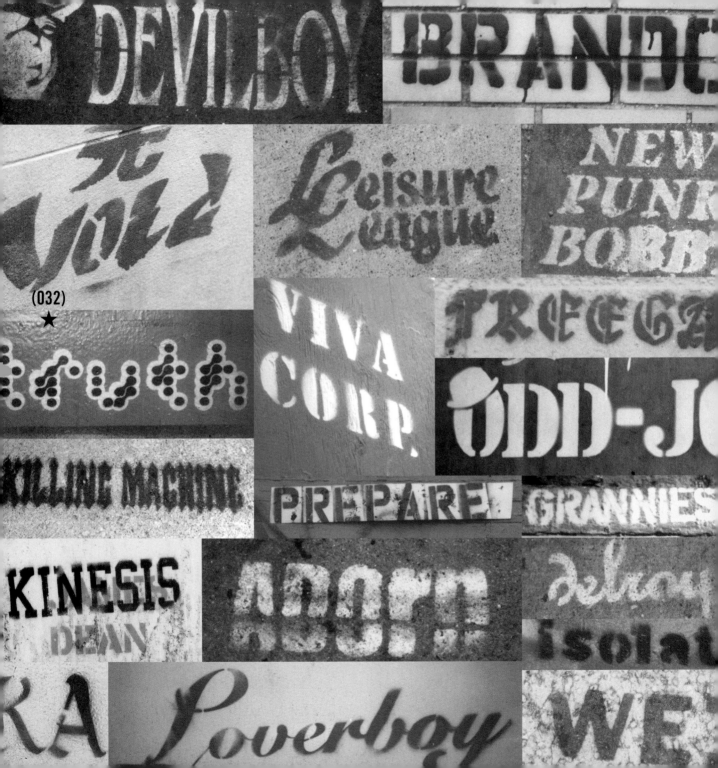

Monkey
Knife
Fight

SITE

B SKYBS

INVIS

ECTRICAL & P

£

BULLET SPACE

RE·DEFINE

USSR

KING of the JUNGLE

YOUTH GONE WILD!

WAKE UP

STYLES

HAND

MAFIA

GOAT

good

Los Jesús Christos

Blin

RUDDY

aqui se venden

Look BACK and LAUGH

FIRE

FUN

RAW TS PETS

MINI

8GB

YOU MUST DIE

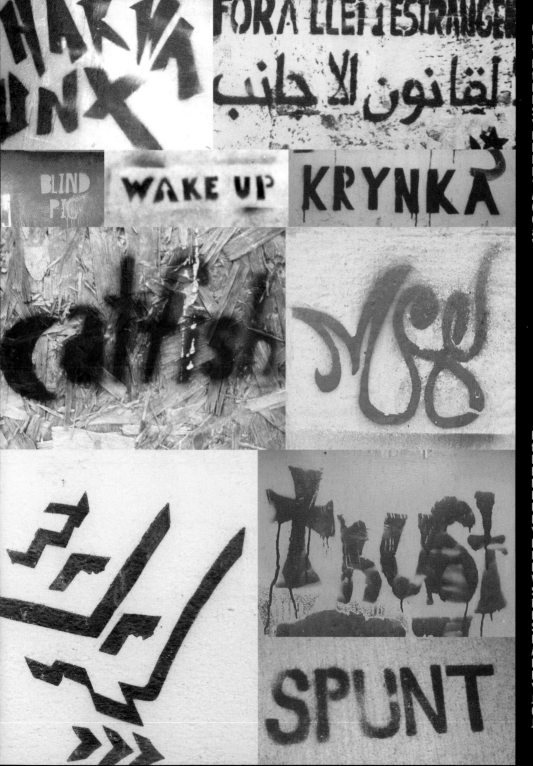

Clockwise from top left: 6th St. Mafia, Bloomington IN; On Top, Stockholm; "The Jesus Christs," Pensacola FL; Dharma Punks, New York City; "No to the Foreigner's Law," Barcelona; Krynka, New York City; MSE, San Francisco; Trust, San Francisco; Spunt, Bloomington IN; FOR, Bristol; You Must Die, Bloomington IN; BOB, Memphis TN; UNI, Brooklyn; Raw Pots Puppets, Pensacola FL; Buddy Holly Lives, Bloomington IN; Nite Goat, San Francisco; Good, Bloomington IN; "Sold Here," Mexico City; Blind Pig, Ann Arbor MI; Wake Up, San Francisco; Catfish, Memphis TN; Fun, New York City; MINI, New York City; Look Back and Laugh, Bloomington IN; Fire, New York City.

(035)

★

Previous two pages, clockwise from top left: Devilboy, San Francisco; Brando, New York City; Lying Boss, Bristol; Ain't, San Francisco; Invisible, New York City; Electrical, San Francisco; Win, San Francisco; Wake Up, New York City; Youth Gone Wild by Ichabod, Pensacola FL; Humid, New York City; Weed, New York City; Loverboy, London; SRA, Bloomington IN; Kinesis, London; Killing Machine, Bloomington IN; Truth, New York City; Void, Leamington UK; Leisure League, San Francisco; New Punk Bobby, San Francisco; Monkey Knife Fight, San Francisco; SCC, New York City; Bullet Space, New York City; USSR, San Francisco; Isolation, Gainesville FL; Adorn, New York City; Prepare, San Francisco; Viva Corp., New York City; Free Gas, New York City; Skabs, New York City; Redefine, Bristol; King of the Jungle, New York City; Delray, New York City; Grannies, San Francisco; Odd-Job, New York City.

STENCIL

At their best and most cryptic, stencils are signs that are both hollow yet simultaneously pregnant with meaning. They are signs without signifiers, images or statements with no clear or fixed meaning. Why is that weird dog on a skateboard painted on the sidewalk? What does it mean? Unlike corporate branding, the images in these open-ended art stencils don't correlate to any specific or defined concept, object, or meaning in the real world. They are not selling anything, teaching you something specific, or telling you to do anything or go anywhere. They have no specific agenda. Sometimes there is a message, but it is open-ended to personal interpretation, such as "You Are Connected" or "Don't Be Afraid" (both phrases painted all over San Francisco in the last couple of years). Stenciled poetry liberates creative writing from the confines of the written page and places it into the line of sight of millions of pedestrians. The imagery or text in an art stencil might have intense or specific meaning to the artist, but there is no way for the audience to know this. The person stumbling across a stenciled image of a sea shell or strange monster face can only bring to that image what they think it might mean, or what the image conjures up from their experience and memory.

POETICS

YOU
ARE
CON
NEC
TED

In addition, a person who sees a rooster stenciled on the sidewalk might also see it on a wall ten feet down the street, or on the train on the way to work, or on the window of an abandoned building all the way across town on their way home. What could this rooster be about? What could it be telling me? Why does it keep popping up in my life? As Russell Howze says, "Traditional art is usually a static experience. One cannot find the same sculpture throughout a city or somewhere else in the world unless it is a replica. Most traditional art is found in galleries, chosen by someone and viewed by a select group of people. These pieces of art can be moved, but usually get placed in other galleries with their own limited viewership. Even when thousands of people see larger exhibits, traditional art's exposure is still limited by the price of admission at the door."[27]

Although they carry no specific meaning, these stencils have the potential to be extremely powerful because they are completely open to the viewer's interpretation. In a world run by the capitalist need for everything to have a fixed meaning within the market economy, the open sign of the stencil can be disorienting, confusing, or even liberatory. I say liberatory because the public is never encouraged to think critically, but instead simply absorb pre-defined meanings. On one level, encouraging people to think off the conveyor belt of work, shop, eat, sleep, work, shop, eat is downright revolutionary.

cont. on page 47

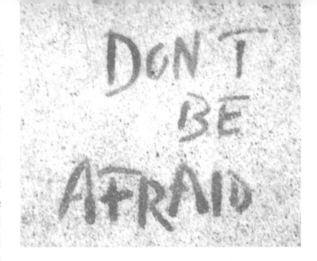

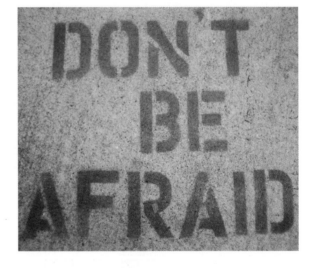

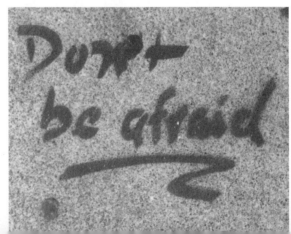

Previous page: You Are Connected, San Francisco.
This page: Don't Be Afraid, all three from San Francisco.

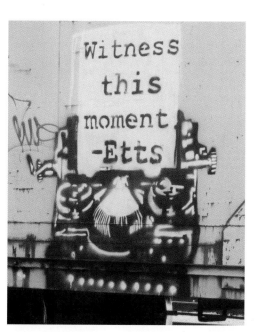

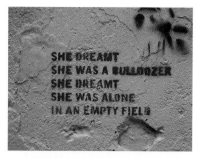

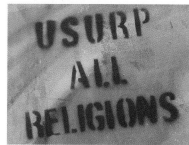

(041)

★

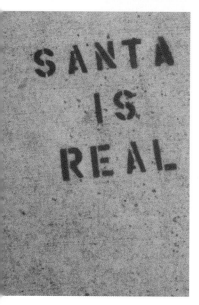

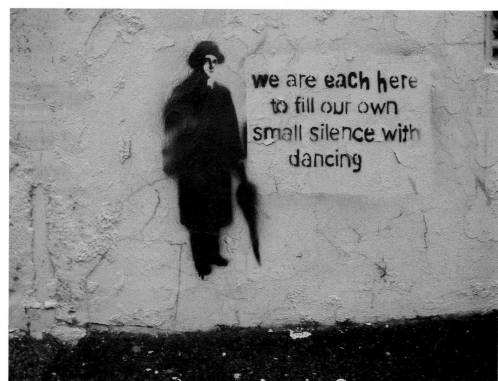

Top row, left to right: Use Your Hands by Megan, Philadelphia; We Live In Public, New York City; "Fight for Women Right Here and Everywhere" by SLINE, Guyana; Now We Are All Slaves by ETTS, New York City; Underneath We're All Lovable, San Francisco. Bottom Row, left to right: All the Warning Signs, San Francisco; "Poets? Take Your Spraycans!" by Spliff Gachette, Paris; This Wall Has Been Intentionally Left Blank by MEEK, Melbourne; Picture Us Somewhere Else by Ben Rubin, Chicago.
Pages 44 & 45: Stop Thinking About Sex, San Francisco.

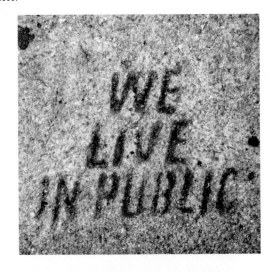

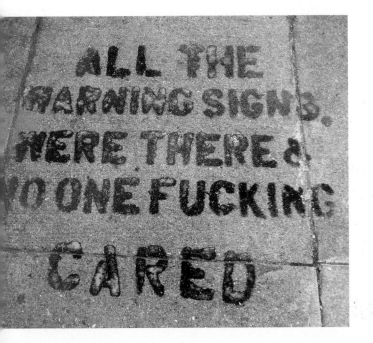

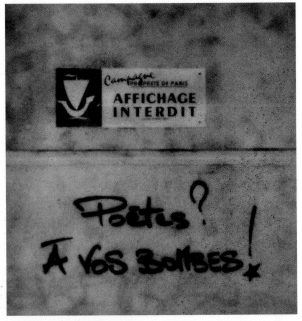

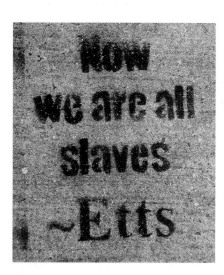

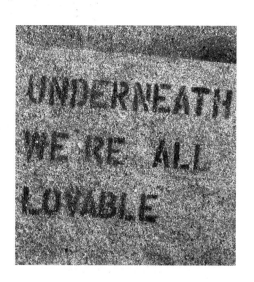

(043)

★

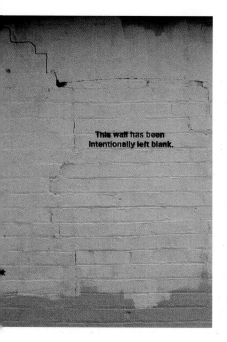

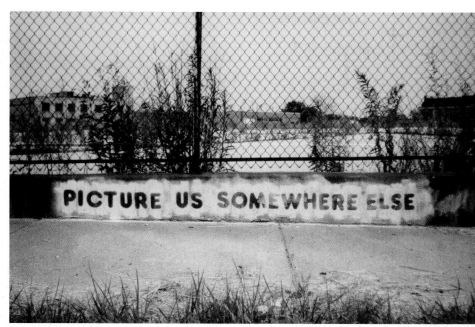

(044)

★

STOP THINKIN

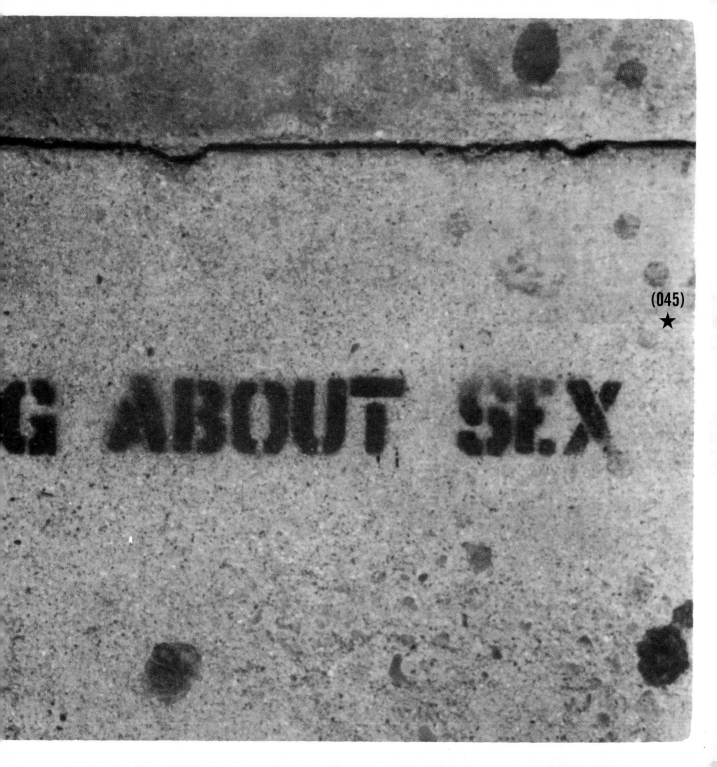

(045)
★

This page, top row: Don't Leave Me This Way, San Francisco; "The True Value Does Not Smell of the Sea," Florence Italy; I See Unspeakable Vulgarity, Boston. Bottom: Quote by Bertolt Brecht, Berlin.
Opposite, top row: Crispin Glover, New York City; Mickey Mouse, San Francisco; Nice Titties, Melbourne. Bottom row: Hulk Smash, Nashville; Blade Runner by SOLVE, W. Palm Beach FL; Snow White by SEVN, Vancouver.

Given that our visual and mental landscape is so cluttered by corporations, it is no surprise that there has been an explosion of stencils of movie stars, cartoon characters and commercial symbols. These stencilers have become human pop-culture copy machines. Unlike traditional graffiti where it takes a significant amount of skill and practice for an artist to use spray paint to create a likeness of a movie or music star, with stencils it's easy. All someone has to do is download an image off the internet, manipulate it to create a black and white likeness, print it, and then cut it out (see the How To File on page 116). I think artists are drawn to these images because they are comfortable and recognizable, they conjure up memories of favorite movies, cartoons, or toys as kids, and set a generation marker on the street. Unfortunately these stencils are rarely very dynamic, and although they might look extremely complex or difficult to do, and be technically impressive, they are rarely memorable and don't expect much from their audience.

All art represents the world that it was created in, and in many ways stenciling is no different. Probably the most common image stenciled is the face. Sometimes famous movie stars, sometimes anonymous public self-portraits, stencilers

cont. on page 55

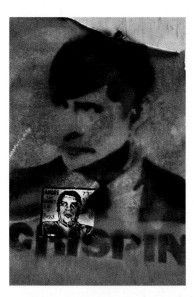

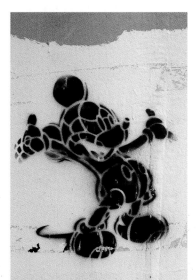

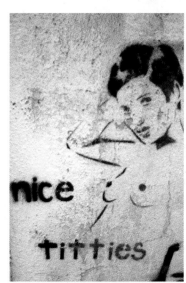

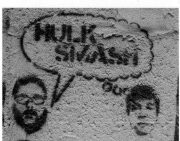

FACES

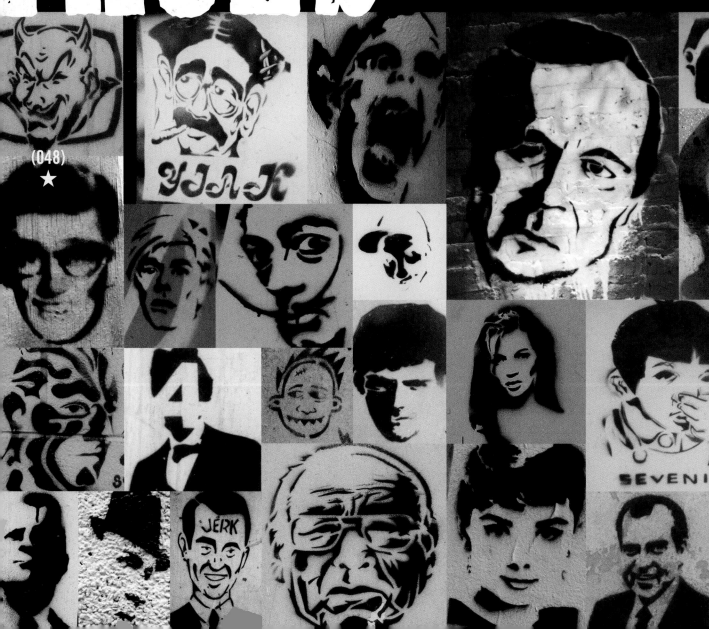

(048)

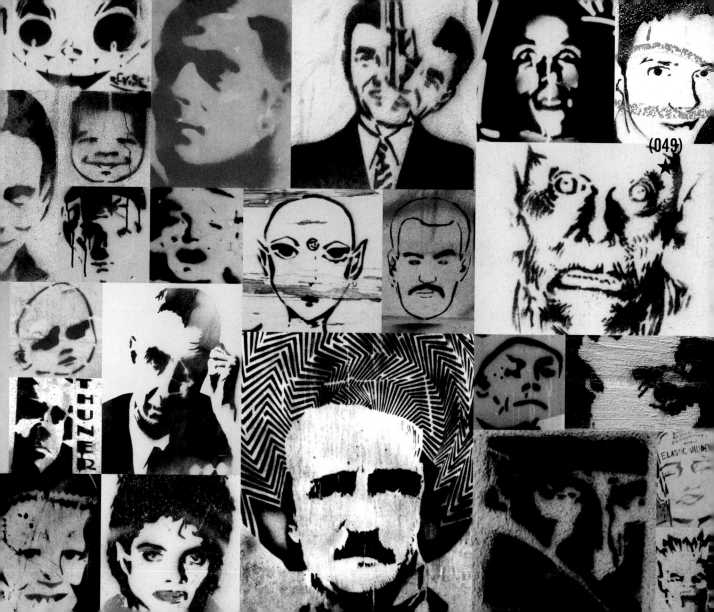

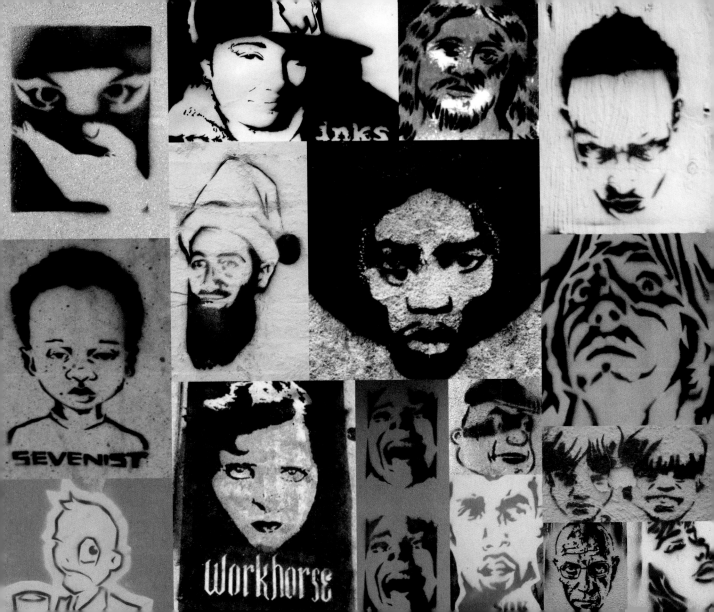

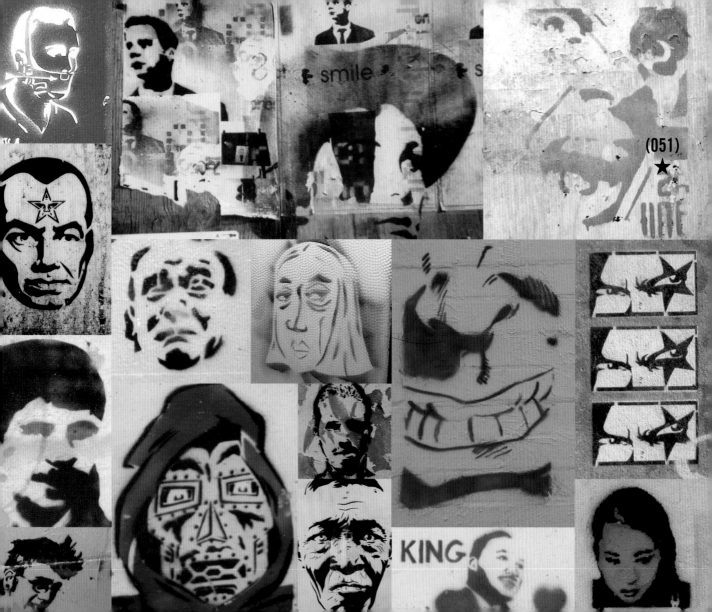

smile

KING

(051)
★

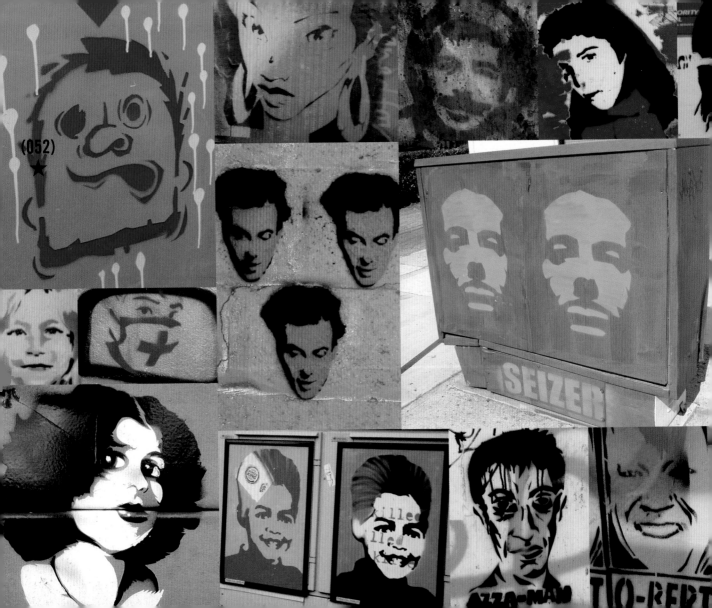

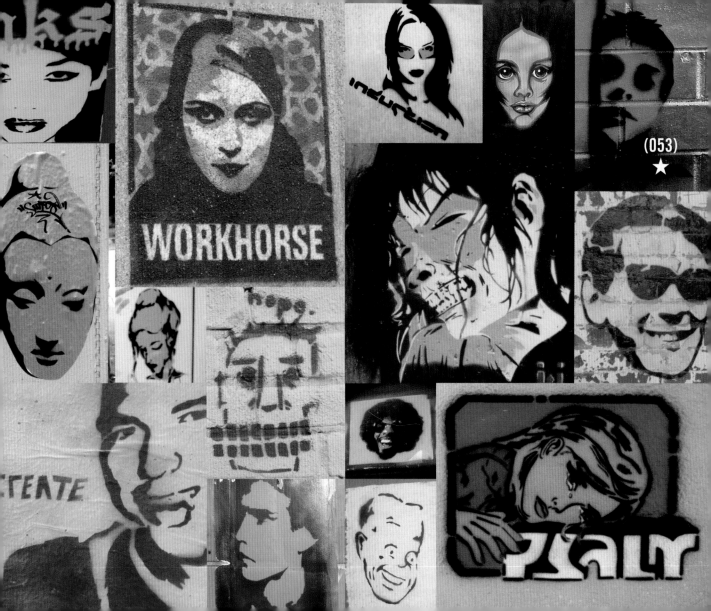

WORKHORSE

(053)

ITALY

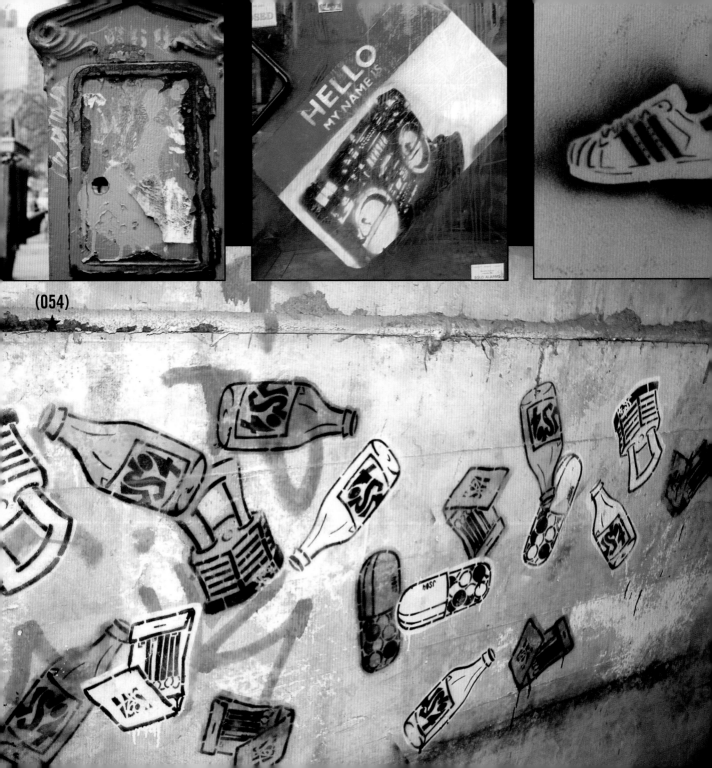

(054)

have painted hundreds of thousands of human faces on streets all over the world. An endless narrative to prove our existence. Stenciling can also shove a culture back into its face, whether it likes it or not. The violence of television and movies is reproduced on the street in the form of hundreds of images of guns and warfare, commodity fetishism plays out in a myriad array of products that have moved from store shelves to representations on walls and sidewalks. Stencilers litter the streets with ghostly reproductions of consumer products and everyday objects. Some artists like to paint brand name sneakers or specific types of subcultural gear, like Rone2's boomboxes. Others recreate the inside of their homes outside by painting stoves, televisions or toasters. Chicago artist JS04 has started painting images of common trash he sees on his block: empty bottles, matchbooks, and rusted locks. The city is always quicker to clean up the paintings of the trash then the trash itself.

Opposite page, top row left to right: Beaker by PROPS, NYC; Boombox by RONE2, Melbourne; Adidas Shelltoe, Melbourne. Bottom: Objects by JS04, Chicago.

This page, top row left to right: Battery, Philadelphia; Joystick by SYN, Melbourne; Toaster, Melbourne; Switch, Melbourne. Bottom row: Photocopier by WITH/REMOTE, St. Paul MN; Sock, Perth Australia; Stove, San Francisco; Cassette by ANALOG, Ann Arbor MI.

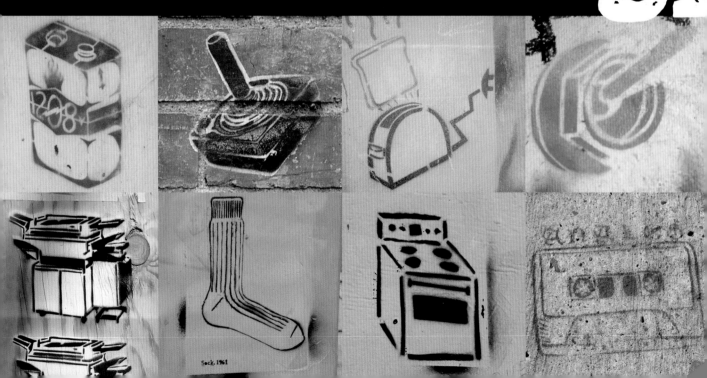

GUNS

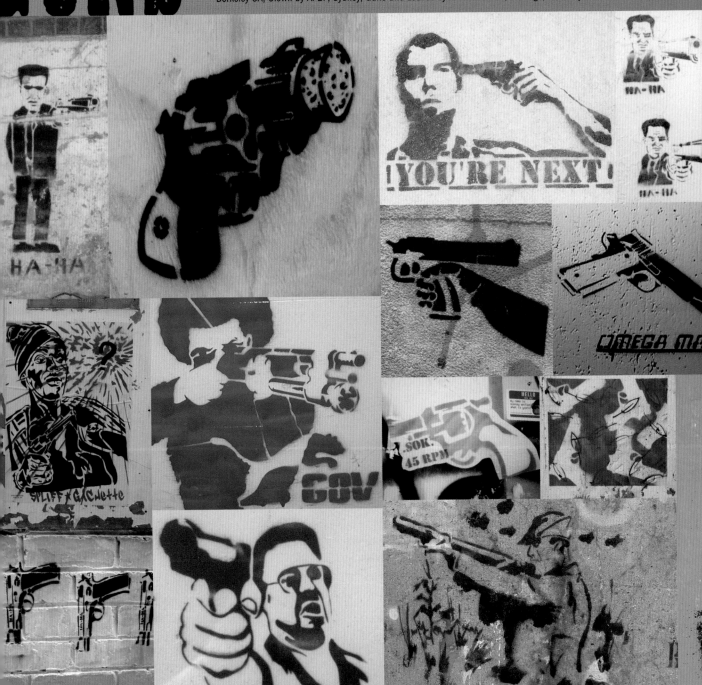

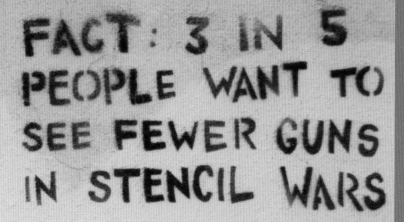

FACT: 3 IN 5
PEOPLE WANT TO
SEE FEWER GUNS
IN STENCIL WARS

(057)
★

Clockwise from top left: TV Lies by Steve Lambert, San Francisco; Weed TV by Josh MacPhee, Chicago; TV Sux, New York City; Mushroom Cloud, Chicago; Missile Screens by Gerardo Yepiz, Ensenada Mexico; Kill Your TV by David Moisl, San Francisco; TV, Bloomington IN; Opiate of the Masses, San Francisco; Console, San Francisco; TV Babies, Barcelona; Mean TV, Bristol.
Opposite: The Building Blocks of Life by John Fekner, Old Westbury NY.

(058)
★

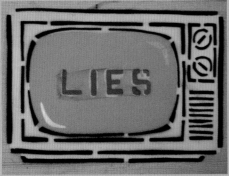

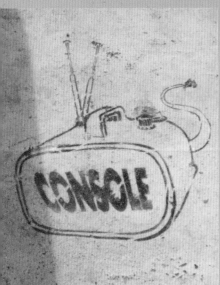

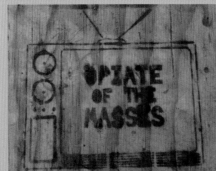
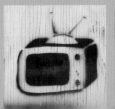
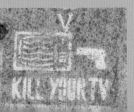

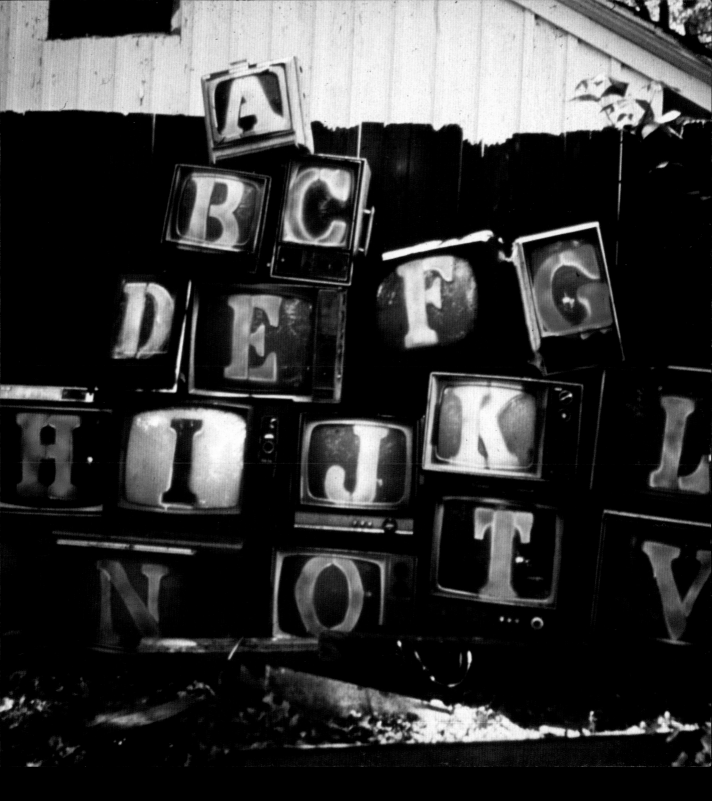

Right: Molotov Thrower by Ben, San Francisco. Left: Resistance Masks, San Francisco.

Opposite left: Bomb the System, New York City. First vertical row: Fight Back, Philadelphia; Molotov, San Francisco; Ape President by BSASTNCL, Buenos Aires; Fist, New York City; Resistance is Beautiful, San Francisco; Liberate, Venice Italy; Silence=Complicity, San Francisco. Second vertical row: Mao, Basel Switzerland; PUA Fist, Barcelona; Vulture President by BSASTNCL, Buenos Aires; Black Panther, San Francisco; Read & Share Empowering Books by Ally Reeves, Nashville; Riot Instigator by TeeTee, Linköping Sweden; All Power, San Francisco.

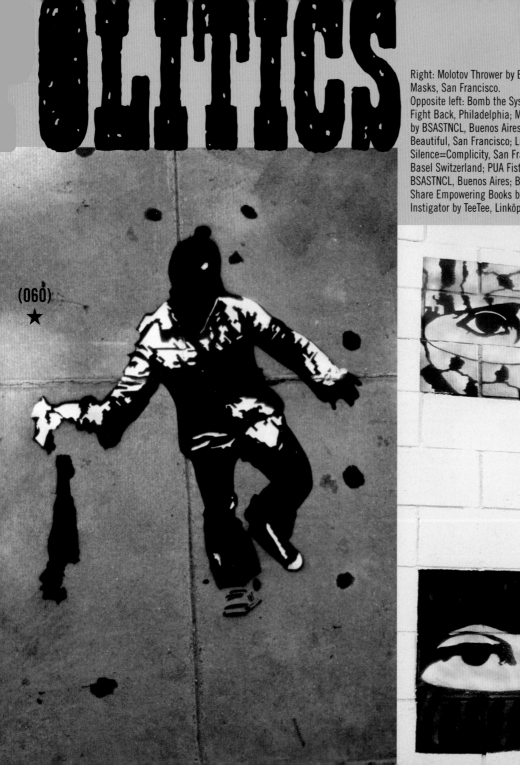

(060)
★

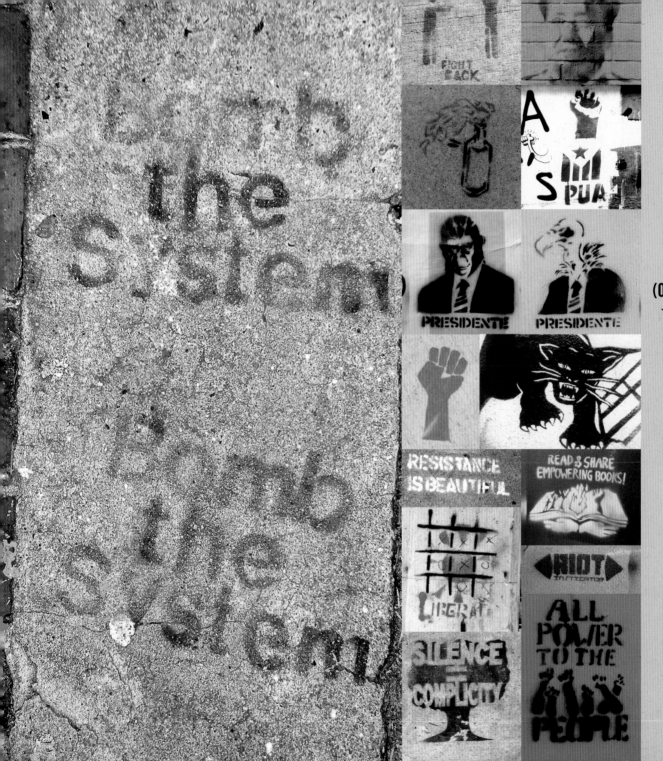

The political street stencil is a direct extension of industrial usage. Political stencils are just as utilitarian as city sanctioned markings, but with a different purpose. Their origins are probably somewhere in Europe in the 40s or 50s, either with fascist or communist parties using stencils as street markings.[28] Political groups have historically used stencils to mark territory and show public signs of organized resistance. Stencils have continued to be a tool in the arsenal of leftist organizations across the globe. The stencil is perfect for their needs because it is much harder to remove than posters and flyers, and it creates a uniform clean image that can be repeated over and over, saturating an area. The practice clearly spread in the 1970s to the Third World and, as discussed earlier, was extremely important in a number of national liberation struggles, particularly those in Nicaragua and South Africa.

Stenciling is so immediate that it lends itself well to political critique. George W. Bush has taken a beating in stencils. The rage against the second gulf war in Iraq has been funneled into thousands of stencils announcing to the world that it was not acceptable. I've collected a gallery of these images on pages 67–71. Although there are many repeated themes, such as crossed out bombs and references to blood and oil, there is also an impressive diversity in imagery. When you don't see your beliefs reflected on television, in the newspapers, or on billboards, stencils make it easy to show

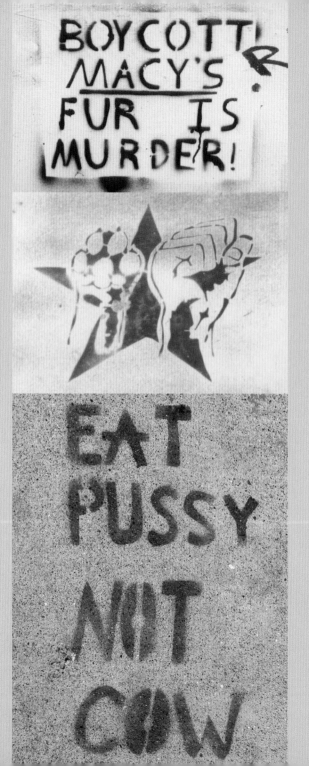

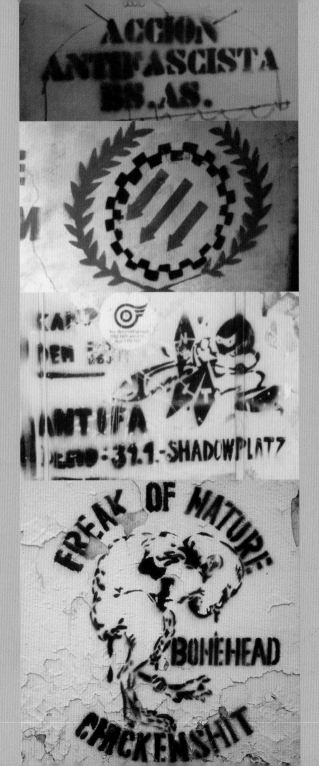

dissent and rejection and share it with the public. As Russell Howze argues, "Artists and activists cannot use these public means of communication because of their high usage price. Even when artists and activists can afford to use these tools, corporate media companies usually turn them down or censor their art. Public advertising creates revenue for ad agencies and isn't free for public usage."[29]

Groups or collectives of artists have often used stencils as part of political campaigns around large social issues. Muralist Eva Sperling Cockcroft discusses using stencils in these groups in her article "Collective Work." She states "Stencils…need little more than a few art supplies, a free evening, a few like-minded friends, and a spirit of adventure. Because of their temporary nature, they are also more appropriate for campaigns and around specific issues targeted toward a particular event or mobilization."[30] Animal rights, anti-fascism, feminism, queer liberation, political prisoners, anti-capitalism, national liberation, police brutality, and prison abolition are all issues popularly dealt with in stencils.

cont. on page 72

(063)
★

This page, top to bottom: "Anti-Fascist Action," Buenos Aires; Anti-Fascist Arrows, Paris; Announcement for Anti-Fascist Demonstration, Dusseldorf; Bonehead-Freak of Nature by David Wilcox, Toronto.
Opposite, top to bottom: Boycott Macy's, New York City; Animal Liberation Fists, Berlin; Eat Pussy Not Cow, San Francisco.

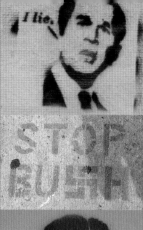

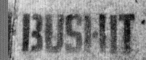

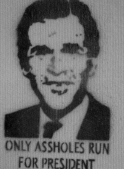

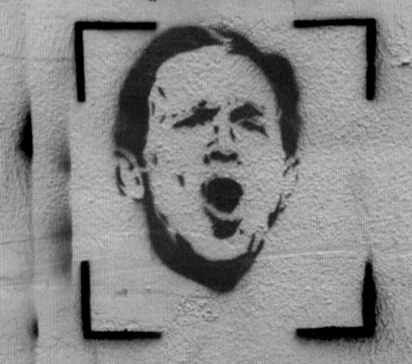

This page, above: Public Urinal, Melbourne. To the right, top to bottom: I Lie, Madison WI; Stop Bush, New York City; Only Assholes Run for President, Ann Arbor MI; Bushit, San Francisco; Devil Bush by CHE, Brooklyn; Virus Bush, Melbourne.
Opposite Page, clockwise starting top left: Busher by RAW, Nicosa Cyprus; Please Wipe Your Feet, Melbourne; Overthrow Bush by Eric E., Chicago; Deceit & Murder by CRUZ, Chicago; Disney War by BSASTNCL, Buenos Aires; Stop Bush, Los Angeles.

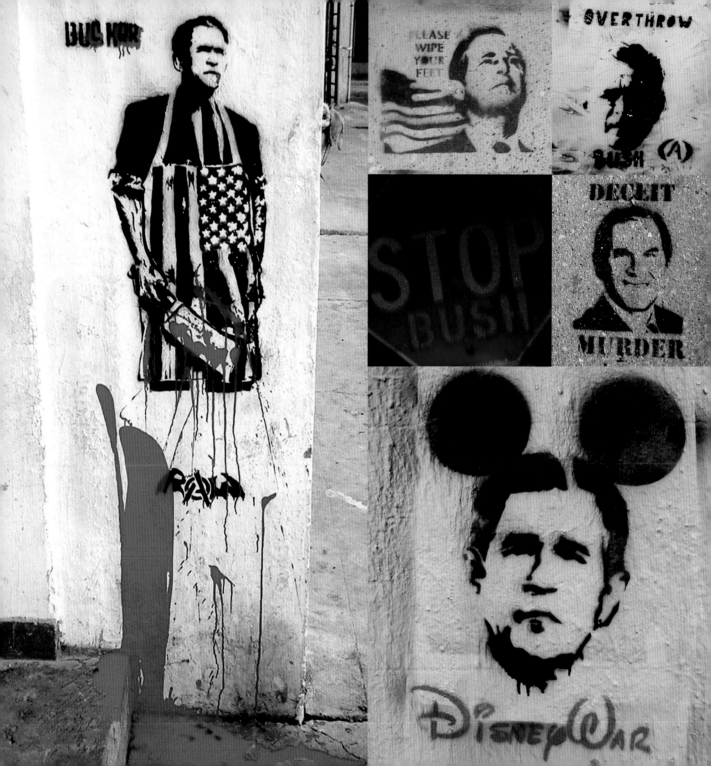

American Style

(066)
★

cheeseburger revolution

PAZ VEGA TRISTÁN ULLOA NAJWA NIMRI DANIEL FREIRE JAVIER CÁMARA JUAN LLANOS and ELENA ANAYA

OSAMA
IS A
BUSH

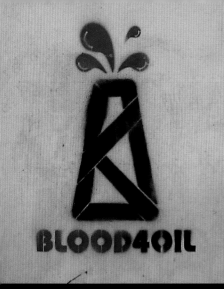

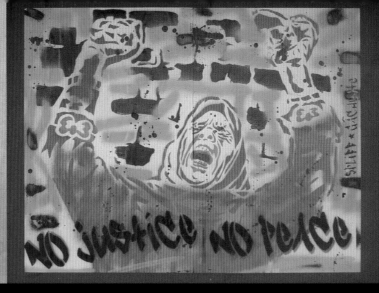

(068)

Top row, left to rigth: Blood 4 Oil, Buenos Aires; No Justice No Peace by Spliff Gachette, Paris; No Bombing by Claude Moller, San Francisco; End Oily War, Vancouver; War is Not a Solution by PHIBS, Melbourne. Second row: "Such a White Heart" by Mandarina Brausewetter, Vienna Austria; Disarm by Chris, Bloomington IN; No War, Chicago; No X Iraq, New York City; No Bombs; London; No War in Iraq, Chicago; Bombing Babies, Ann Arbor MI; "Peace for the Whole World," San Francisco. Third Row: Soldier, London; End Sanctions in Iraq, Ann Arbor MI; No Bush No Saddam, Santiago; No Bombs by TEMPER, Athens Greece; No War by JS04, Chicago; stopwars.org, Buenos Aires; Stop Wars, San Francisco; No War on Iraq, Washington DC; Support the Troops that Break Ranks, San Francisco; No War by ETC, Perth Australia.

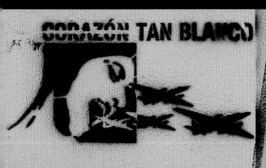

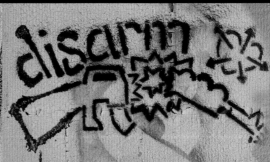

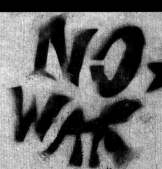

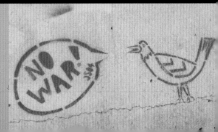

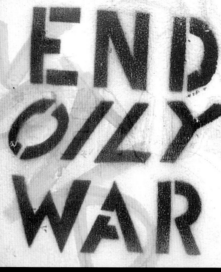

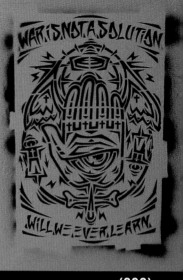

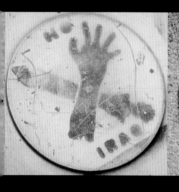

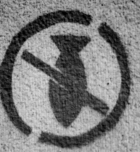

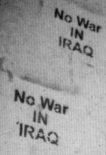

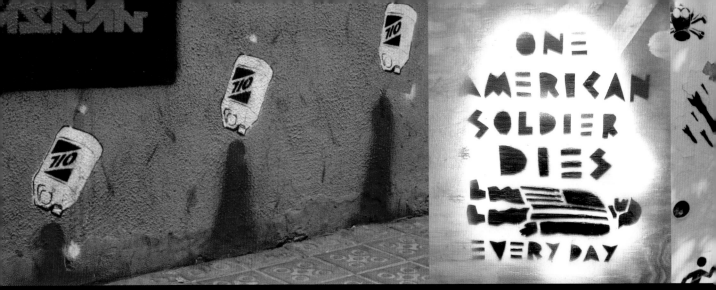

(070)
★

Top row, left to right: Oil & Blood by JSTK, Barcelona; One American Soldier Dies Everyday by Seth Tobocman, New York City; Fleeing Bombs, Greneda Spain; No War! Fuck the Army by Spliff Gachette, Paris; War Casualty, Boston. Middle row: Stop War by ETC, Perth Australia; Make Stencils Not War by DLUX, Melbourne; Bombs Solve Nothing, San Francisco; Once Again by Colin, Ann Arbor MI; Who Fights the Wars the Rich Start?, San Francisco; No Mass Murder of Iraqis, New York City; Bomb Carrier by SINS, Perth Australia; 911, Barcelona; War Kills, San Francisco; "My Brain Knows in Such a Way" by Mandarina Brausewetter, Vienna Austria; I Can't Sleep, Melbourne; No Blood For Oil, San Francisco; No War!, Santiago; Make Out Not War by Eric E., Chicago; It's a Holiday in Afghanistan, San Francisco; Stop U$ Terrorism in Iraq, Boulder CO; No War, San Francisco; Thanks for War $UV, San Francisco; Knife Mouth, Bloomington IN; War Coathanger, San Francisco.

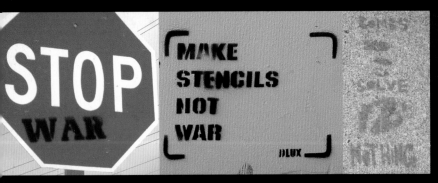
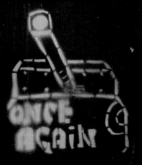
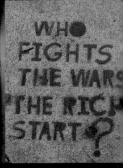

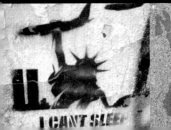

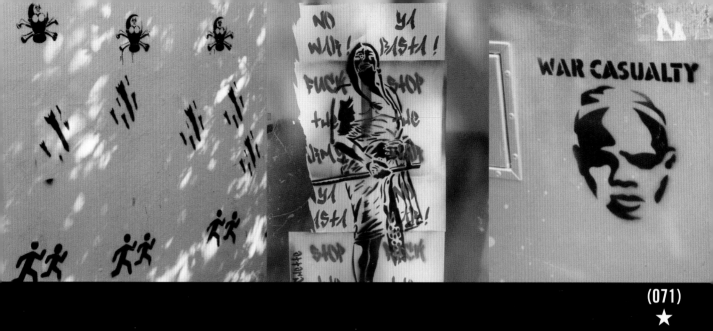

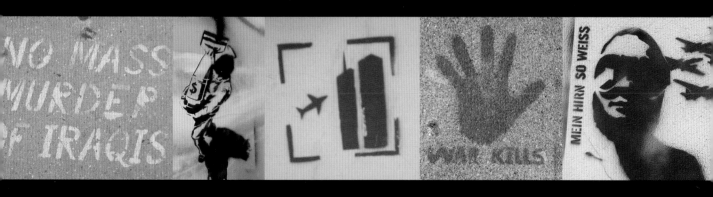

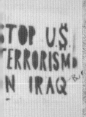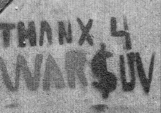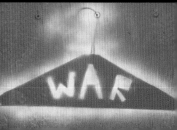

political stencils don't always have to be didactic or about large overwhelming social issues. Artist Logan Hicks explains, "The first [sten]cil I saw was this skull with flames coming off [t]he head. It was on a sharp turn that was on an [r]amp to the interstate. It was [done by] this [guy] named Bob Kathman. He had an accident at [th]e very spot one night when it was raining. Bob [was] pissed he didn't know it was a sharp turn, so [he] called up the transportation department and [war]ned them that the turn was too sharp to take [and] it was causing accidents. The transportation [dep]artment said they would put a sign up saying [don']t take the turn faster than thirty mph, but it [nev]er happened. He got annoyed and went out one [nigh]t and sprayed this stencil on the turn where [his] van had crashed."[31] Artists Scout and Stain [hav]e also undertaken stenciling as civic duty with their Free School Neighborhood Project. As Scout explains, "We decided to put up a lot of painting[s] in the neighborhood that I was living in at th[e] time. Like most of downtown Albany's neighbo[r]hoods, it is a predominately African-American or[ea] filled with once-beautiful, decaying old home[s.] Abandoned spaces and boarded-up windows a[re] the norm. Stain and I decided to borrow some [of] those spaces and make an offering to the peop[le] who live there." They stenciled delicate and beau[ti]ful images of children from the neighborho[od] onto weathered abandoned buildings and plywo[od] covered windows.[32]

This and opposite page: All stencils by STAIN and SCOU[T,] Albany NY.

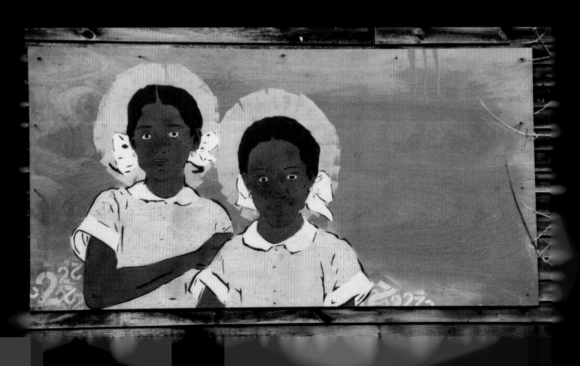

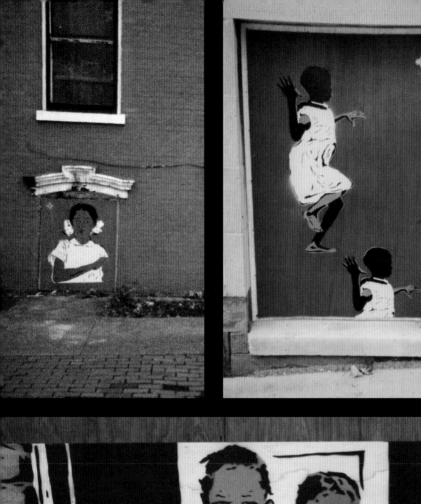
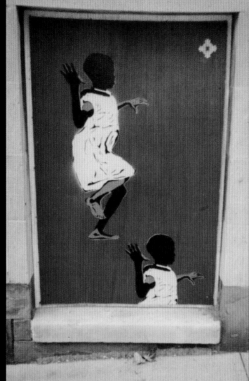

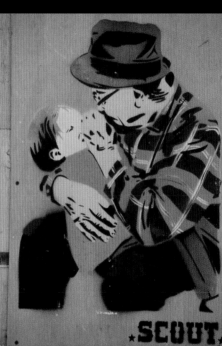
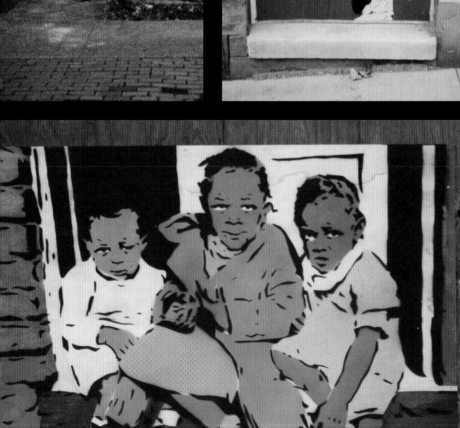
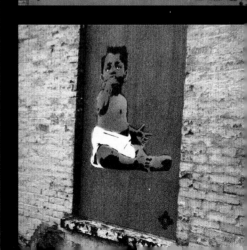

(074)
★

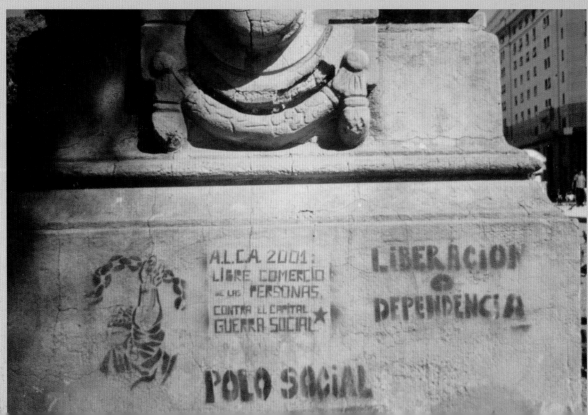

Argentina has been the site of a huge stencil revival. After facing years of corruption and an externally imposed and unrealistic economic program, millions of people took up protest in December 2001. The sheer numbers of people in the streets overthrew the status quo. The vacuum of power created was quickly filled with large neighborhood assemblies ("Asemblea Popular") and worker-run factories. Stencils were an integral part of the uprising and the democratic culture it left behind. Almost every protest had a stencil contingent, and as Ryan Hollon states, "What the massive uprising left behind was a cultural memory of resistance. In Buenos Aires, Argentina's capital, this memory has been inscribed onto the city walls. On nearly every bank and government building, stencils bear witness to the fresh legacy of widespread mobilization."[33]

Hollon continues, "Throughout the period of intense uprising, social possibilities were rearranged and identities were revolutionized- if only temporarily. During this brief and powerful period, stencils offered the possibility of alternative public expression to the sea of new groups and individuals looking to get out their call for a new Argentina. Many in the middle class suddenly became street artists combating global capital. Government workers took the streets prepared to stencil on government walls.... The poor, who have historically been used by politicians to paint murals during political campaigns, could now use

ARGENTINA

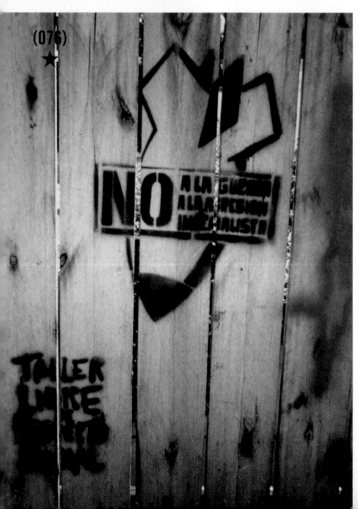

murals to tell all the politicians to get the hell out of their country."[34] Protests were happening daily for many months and each one brought a fresh batch of stencils to the streets. Jenny Schockemohl talks about walking these streets, "I walk off the subway and spraypainted in front of me reads, 'the Final Rebellion.' One block down...there is a whole wall covered with popular expressions in paint. One says 'Globalization will Destroy Itself.' It is quite clear that the people have taken back this city."[35]

Out of the protest movement sprung artist collectives that used stencils to "propose political alternatives and advocate alternative politics." Hollen lists some of the groups: "El Ejercito de Artistas" ("The Army of Artists"), "Grupo de Arte Callejero" ("The Street Artists Group"), and "El Taller Popular de Serigrafía" ("The Popular Screen Printing Workshop").[36] Other less specifically political groupings like BSASTNCL have also emerged.

All Argentina photos from Buenos Aires.
Top left: "First of May." Top right: "Enough Already!" by BSASTNCL.
Bottom: "No to the War, No to the Imperialist Aggression."
Previous page, left to right: "This System is Going to Fall, December 19&20, Everybody to the Street;" "Now or Never;" "The Solution is Self Management, Popular Assembly."
Page 74, top row left to right: "Wake Up;" "Your Savings Box;" "Where Was the Fire." Second row: Don't Do It; "December Heating Up;" "The Step." Bottom: "Social Pole" and "Liberation or Dependency."

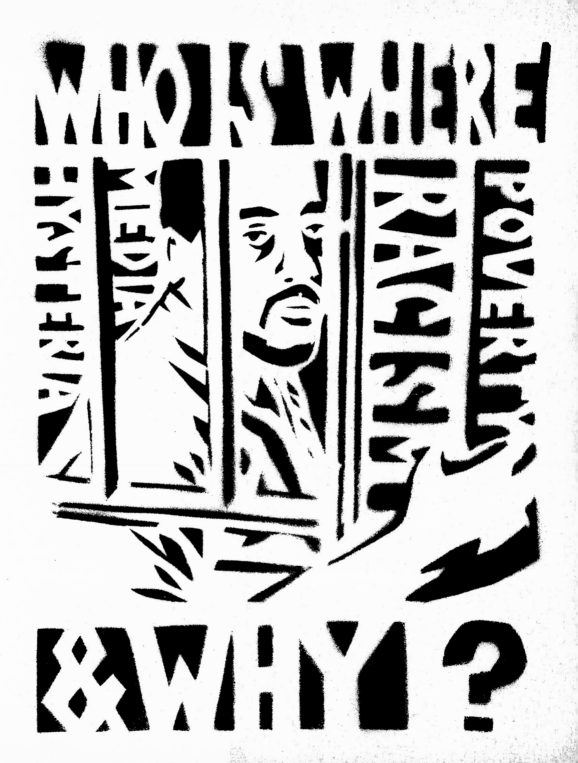

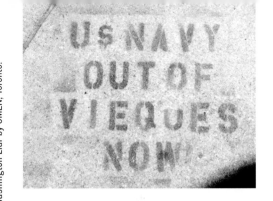

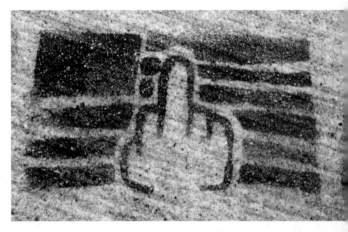

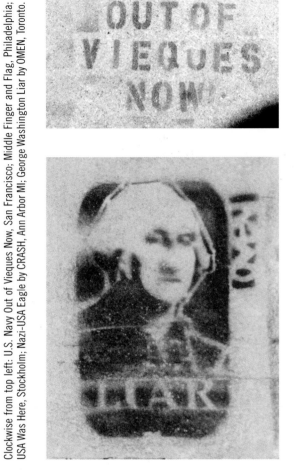

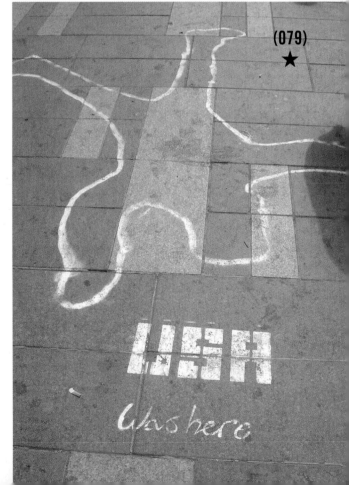

(079)
★

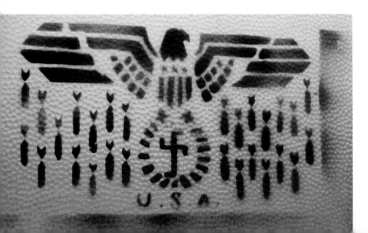

Clockwise from top left: U.S. Navy Out of Vieques Now, San Francisco; Middle Finger and Flag, Philadelphia; USA Was Here, Stockholm; Nazi-USA Eagle by CRASH, Ann Arbor MI; George Washington Liar by OMEN, Toronto.

GROUNDWORK

Groundwork: The Anti-Nuke Port Stencil Project was organized in 1989 by two New York artists and activists, Ed Eisenberg and Greg Sholette. Both were extremely concerned about a proposal to build a Navy base on Staten Island that would dock ships with the capability of carrying nuclear weapons. In order to try to build mass opposition to the port, they organized twenty-eight artists to create stencils to oppose the building of it. Each artist developed their own unique anti-nuclear stencil, but when they were painted on the street, an additional stencil was added that clearly marked how far that specific location was from the proposed base location. Literally thousands of these stencils were painted on street corners all over New York City. As a way to ensure media attention they even invited media representatives to accompany them on their stencil outings. In addition to the street stenciling, a number of the stencils were also used on signs and banners at anti-nuclear protests.[37]

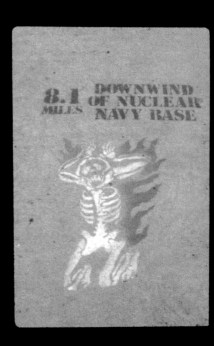

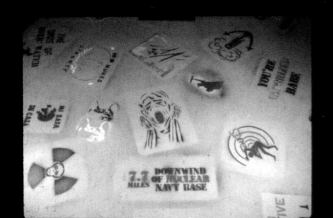

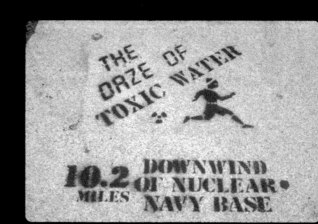

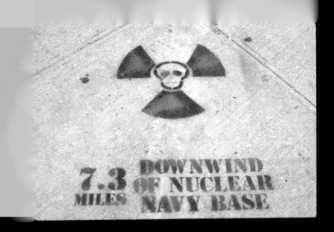

7.3 MILES **DOWNWIND OF NUCLEAR NAVY BASE**

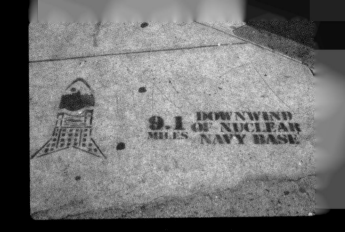

9.1 MILES **DOWNWIND OF NUCLEAR NAVY BASE**

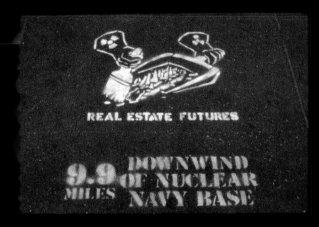

REAL ESTATE FUTURES

9.9 MILES **DOWNWIND OF NUCLEAR NAVY BASE**

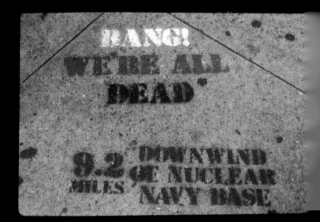

BANG! WE'RE ALL DEAD

9.2 MILES **DOWNWIND OF NUCLEAR NAVY BASE**

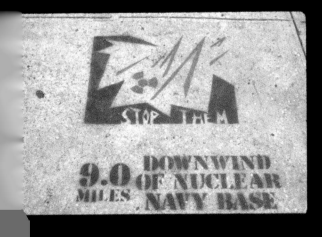

STOP THEM

9.0 MILES **DOWNWIND OF NUCLEAR NAVY BASE**

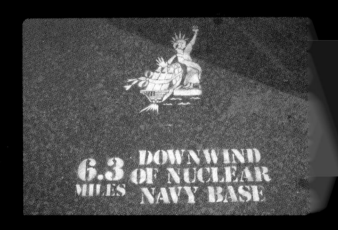

6.3 MILES **DOWNWIND OF NUCLEAR NAVY BASE**

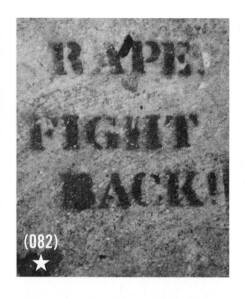

(082)

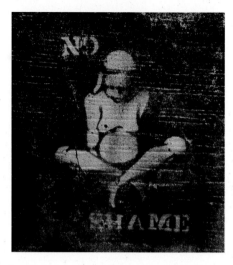

First vertical row from top: Rape. Fight Back!, New York City; Not Your Bitch, San Francisco. 2nd row: Zeb U Know U Raped Her, San Francisco; No Shame, Philadelphia; Mine, Gainesville FL. 3rd Row: Full on Kiss My Clit by Liza Jane, Ann Arbor MI; Be Your Own Heroine, San Francisco; Shoot Rapists Not Heroin, San Francisco.

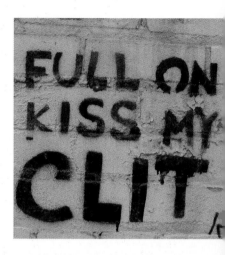

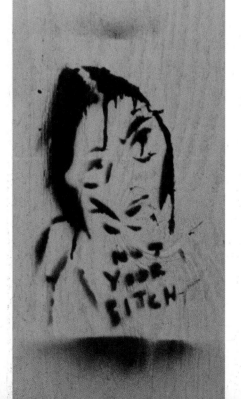

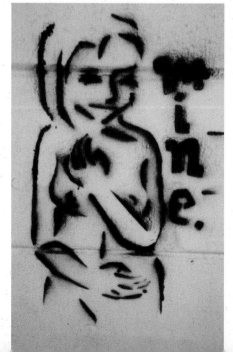

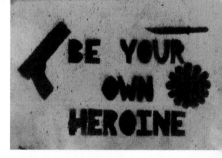

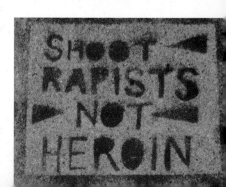

Below top: A Queer Was Bashed Here, San Francisco. Bottom: Gay Dad, Chicago.
Right, top to bottom: Queer as Fuck by Sam, Bloomington IN; Queer Revolt, Boston; Lucky Dyke, San Francisco.

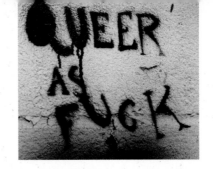

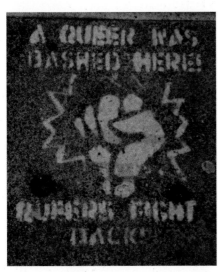

(083)
★

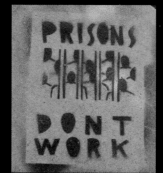

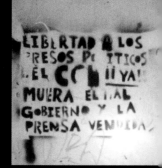

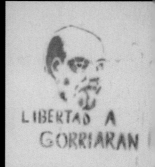

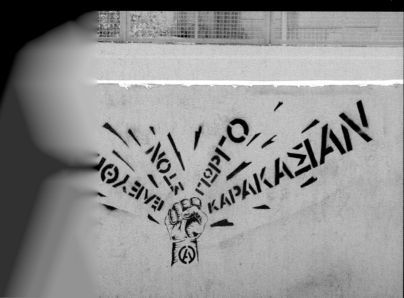

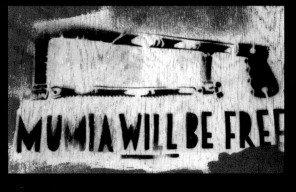

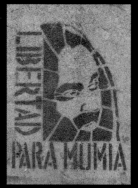

(085)
★

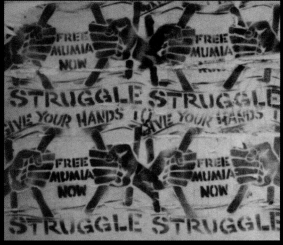

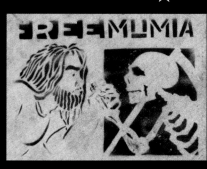

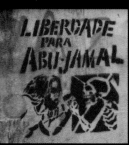

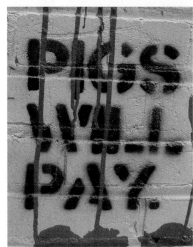

ALTO AL
ABUSO
POLICÍACO

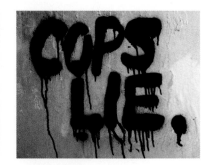

PIGS
WILL
PAY.

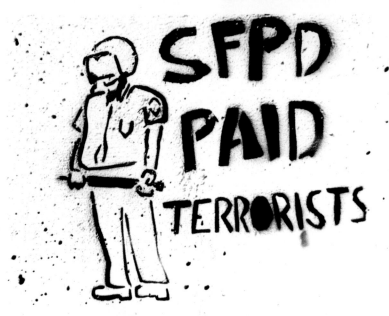

COPS
LIE.

SFPD
PAID
TERRORISTS

(086)
★

Clockwise from top left: "Stop Police Abuse," Washington DC; Pigs Will Pay, Ann Arbor MI; Cops Lie, Boston; SFPD Paid Terrorists, San Francisco; "Police State," Quebec City; Pig, Nashville; Fuck Cops, Louisville; Cops Chasing by BANKSY, Bristol; Klan Cop Puppet, San Francisco.

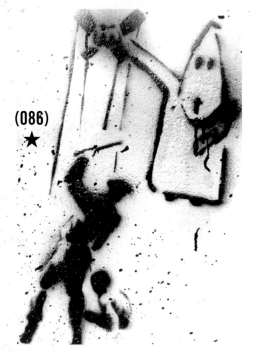

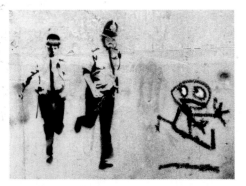

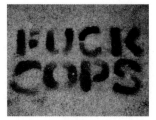

FUCK
COPS

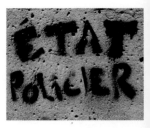

ÉTAT
POLICIER

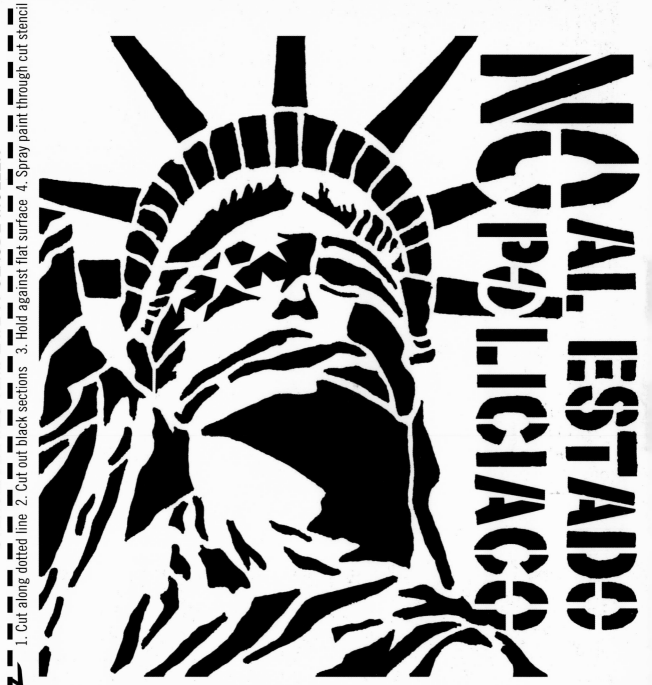

STENCIL PIRATES TEMPLATE F: CLAUDE MOLLER

1. Cut along dotted line 2. Cut out black sections 3. Hold against flat surface 4. Spray paint through cut stencil

NO AL. ESTADO NO POLICIACO

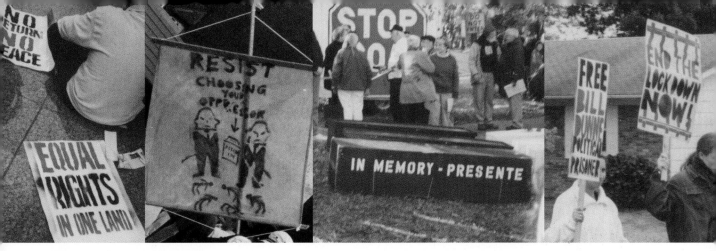

At some point activists realized that stencils could be used to not only state a specific political message, but that you could use them to try to attract people to a specific political event at a specific time. Like the early text stencils that music clubs used to announce upcoming bands, these calls for protests and marches are an alternative form of promotion, but since the stencils are painted directly on the sidewalk they reach as general and wide an audience as possible. It is now common in San Francisco and other cities to look down and see a stencil announcing a dyke march or anti-gentrification protest. Activists also often use the reproducibility of stencils to quickly produce dozens of protest placards with repetitive bold graphics or to put explanatory text on puppets and other protest props.

(089)
★

Top, left to right: Palestine Rally Placards, Chicago; Resist Choosing Your Oppressor Banner at the 2000 Republican National Convention, Philadephia; In Memory Coffin at the School of the Americas Protests, Fort Benning GA; Protest Placards Against the Lockdown at Marion Federal Prison, Marion IL.
Bottom, left to right: Announcement for Anti-Globalization Protest, Praque; Caminata Walk, San Francisco; Dyke March, San Francisco.

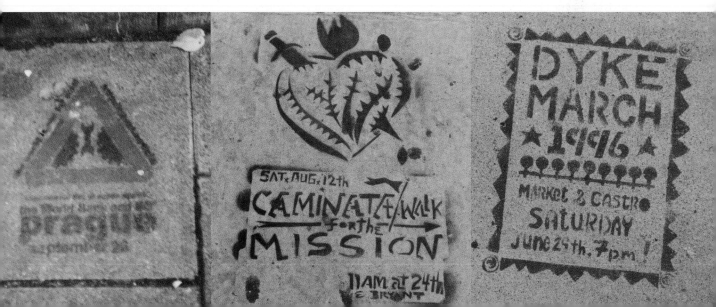

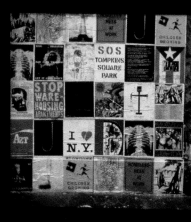

Temporary groups or collectives of artists have often used stencils as part of political campaigns around large social issues. Gentrification and homelessness have consistently been one of these issues tackled by stencil-wielding artists and activists. In 1984, the New York City based activist artist group Political Art Documentation/Distribution launched its "Not for Sale" project in the Lower East Side. PAD/D organized dozens of artists to create street-based art that dealt with housing issues. Many created stencils, which were either directly painted on the street or stenciled on paper and then wheatpasted onto the street.[38] Since then, individuals and organized groups have stenciled anti-gentrification messages in dozens of cities. I'm not sure how to judge the effectiveness of these stencils, but in San Francisco and New York they have been a strong visual part of larger campaigns against the destruction of diverse working-class communities. Possibly the stencils' greatest contribution in the gentrification battle is that they clearly mark a contested territory and step outside accepted communication channels to bring the issue into public view.

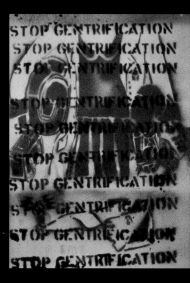

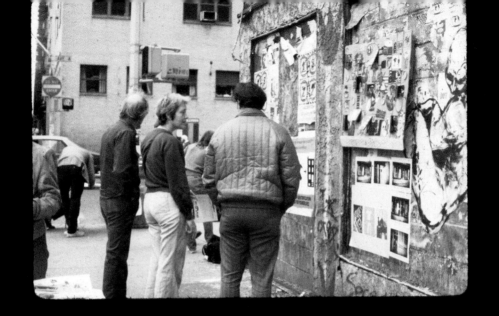

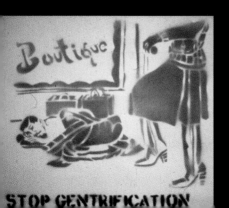

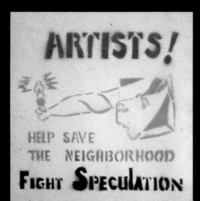

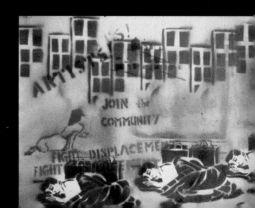

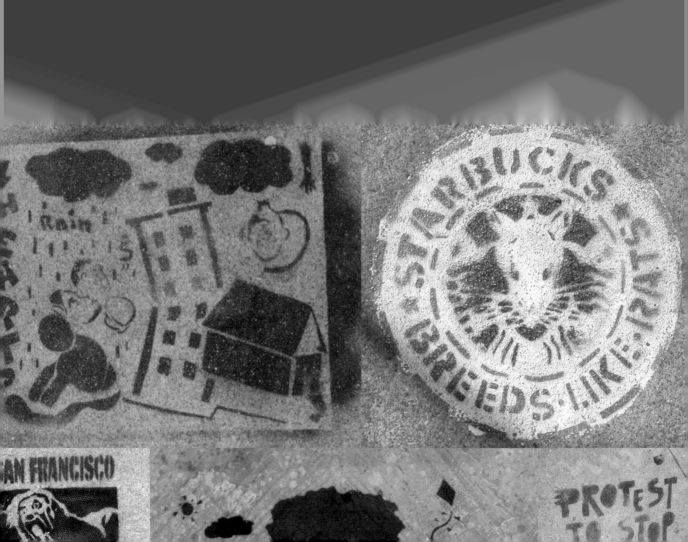

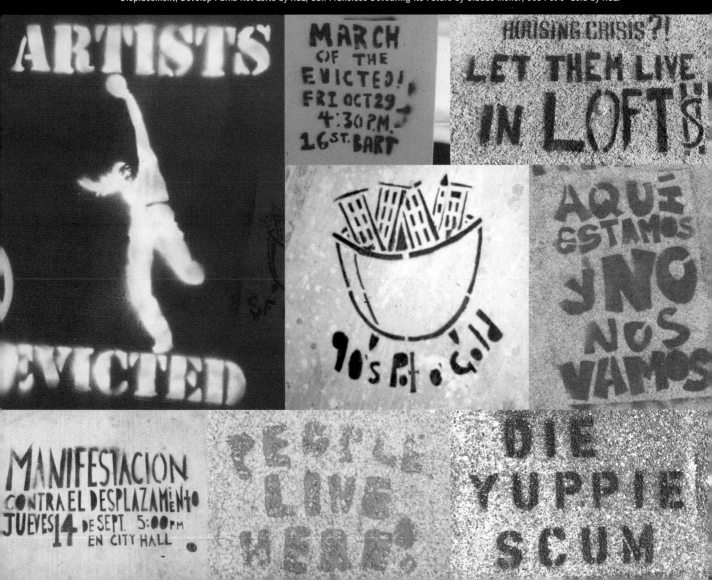

Clockwise, from top left: Chicago Real Estate Developers by Josh MacPhee, Chicago; Squat Sun, Philadelphia; Rare Piece of Sidewalk $1500, Chicago; Greedy Politicians and Developers Love Chicago by Josh MacPhee, Chicago; Yuppie Go Home, Brooklyn; Squat Heart, Bloomington IN; Refugees Yes! Yuppies No!, Melbourne; This Building Destroyed a Community Garden, New York City; "Houses for All," Berlin; Squat! by Sabrina Jones, New York City; Gentrifuct, Melbourne; Rent is Theft, Toronto; (Insert Gentrification Here), Louisville.

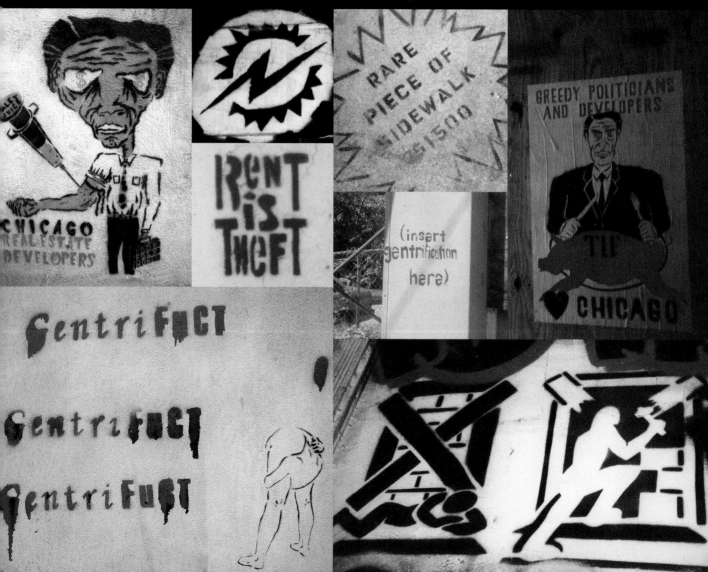

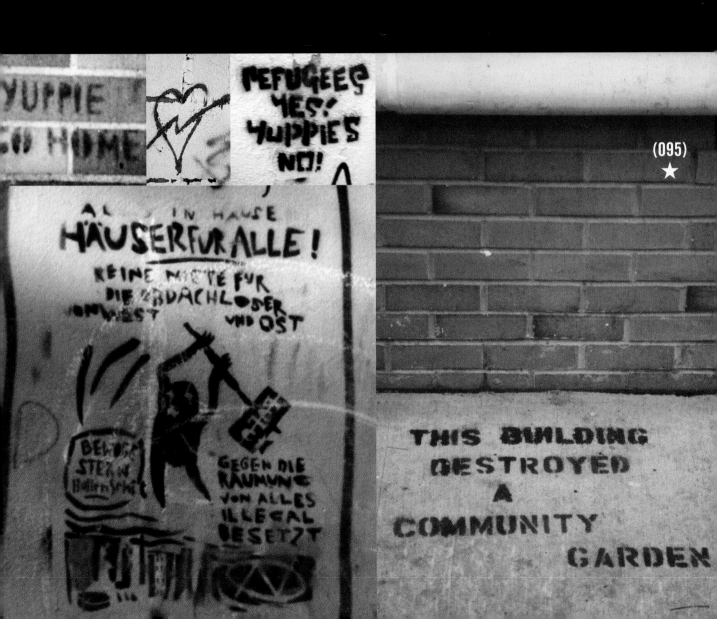

YUPPIE GO HOME

REFUGEES YES! YUPPIES NO!

ALLE IN HAUSE
HÄUSER FÜR ALLE!
KEINE MIETE FÜR DIE OBDACHLOSER
VON WEST UND OST

BERLIN STEAM Bedürfnishaft

GEGEN DIE RÄUMUNG VON ALLES ILLEGAL BESETZT

(095)
★

THIS BUILDING
DESTROYED
A
COMMUNITY
GARDEN

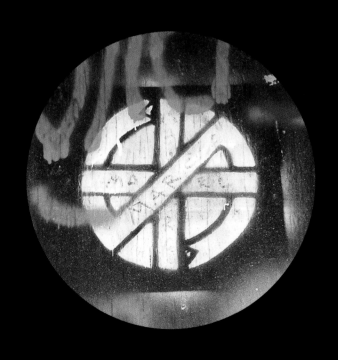

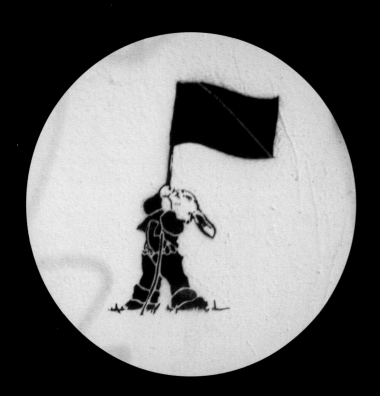

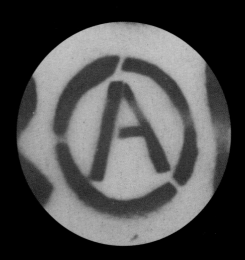

As in Europe, stencils have been used by communists and socialists in the United States, but the main political group they have been connected to here is anarchists. The stenciled logo of the anarchist punk band Crass showed up on their first records in 1978, and images of stenciled anti-militarist banners are reproduced on the poster that came with the 1979 album *Stations of the Cross*. Five years later, Seth Tobocman published his now famous "You Don't Have to Fuck People Over to Survive" stencil-based narrative in *WW3* #4. Some of these images, including the namesake panel, were also painted in the street and on squatted buildings in the Lower East Side. Seth painted his first street stencil in 1983 against the U.S. invasion of Grenada and was involved in other stencil projects with PAD/D and the squatted gallery Bullet Space among others.[39] When Seth's first book was published in 1990 and included that original series of images, these stencils were quickly picked up and reproduced by anarchists and squatters all over the world. Over the past decade, dozens of young anarchists have cut out both "You Don't Have to Fuck People Over" and Crass logo stencils and painted

them in their respective cities. Stencils are now and quite possibly forever the aesthetic of anarchy.

The aesthetic and form of the stencil lends itself perfectly to anarchism in the U.S. In a country where both public expression and anarchism are criminalized in different ways, spreading a message by publicly breaking the law is too much of a temptation to resist. The rawness and urgency of dripping black stencils all over a city amazingly captures how anarchists feel about themselves and their message, like a dirty beacon in a sea of sterile uniformity. I know from personal experience that anarchists living on the margins often can't afford to print posters or build silkscreen setups, yet almost everyone can find cardboard, get a knife at a copy shop, and buy or steal a can of 99¢ spray paint. Renewed interest in anarchism and anti-authoritarianism fueled by the alternative globalization movement has created a new generation of anarchists that have taken to the streets, making themselves and their politics visible to anyone walking the streets in major cities all over the world.

From left to right: San Francisco; Ann Arbor MI; Oakland.
Previous two pages, left to right: Crass Logo, Ann Arbor MI; Blag Flag Bunny by CIVIL, Melbourne; Circle A, Oaxaca City Mexico.

(098)
★

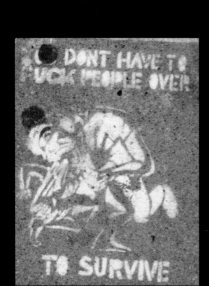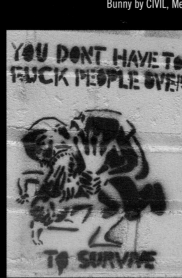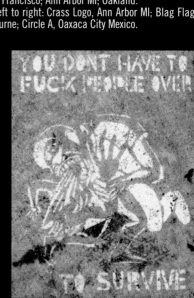

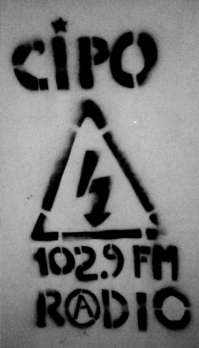

CLASS WAR

JUST DO IT

CLASS WAR NOT RACE WAR

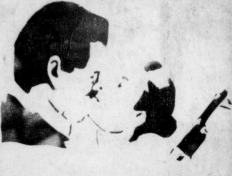

www.anarchistyouth.net

Clockwise from top left: Hands & Leaves by Josh MacPhee, Memphis TN; CIPO Radio, Oaxaca City Mexico; Class War Not Race War, New York City; Anarchist Youth, London; Question Authority, San Francisco; Start a Revolution, Burning Man NV; Don't Vote, Bloomington IN; Stop Believing in Authority, Washington DC; Man with Black Flag by RAW, Nicosia Cyprus; Class War, San Francisco; Rats by BANKSY, London.

(099)
★

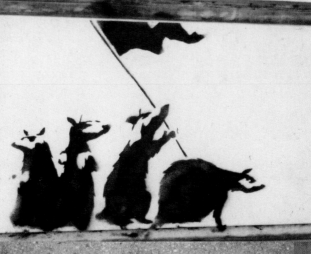

QUESTION AUTHORITY

START A REVOLUTION

STOP BELIEVING IN AUTHORITY START BELIEVING IN EACH OTHER

DON'T VOTE

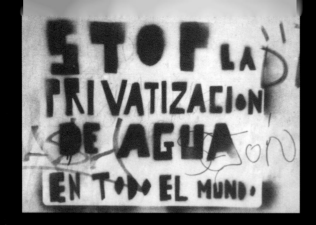

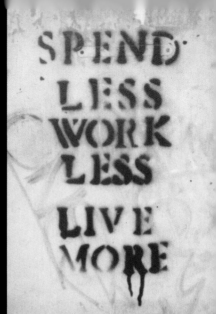

Clockwise, from top left: "Stop the Privitization of Water in the Whole World," Barcelona; Spend Less Work Less Live More, Bloomington IN; Kill Corporations, Philadelphia; Anti-Capitalist Bloc, London; "Protest Against the Summit," Prague; Is Capitalism a Disease?, Boston; Live Free, San Francisco; Stop Helping Them Kill You? Bloomington IN; Who Owns You?, Bloomington IN; Fight the Rich, Philadelphia; Fat Business Man, Perth Australia; United We Shop, New York City; Consume, Melbourne; Slavery, Pittsburgh; I Love Corporate Extinction, Chicago; "Equality," Barcelona.

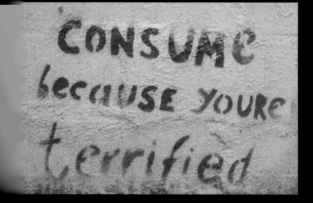

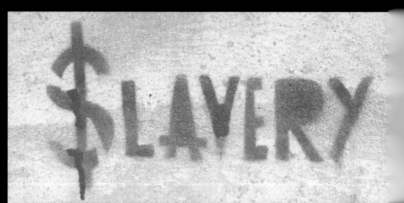

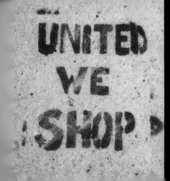

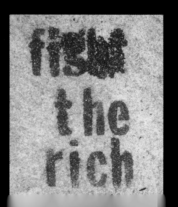

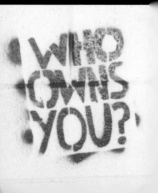

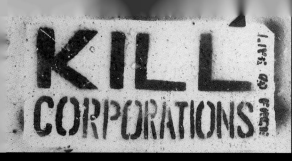

KILL CORPORATIONS

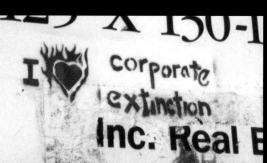

I ♥ corporate extinction
Inc. Real E

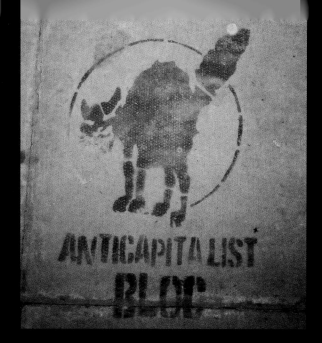

ANTICAPITALIST BLOC

igualtat!

ClonCorp

ANTISUMIT 2000
PROTI MMF A
SVĚTOVÉBANCL
26.9-28.9. PRAHA

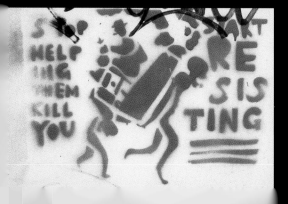

STOP HELPING THEM KILL YOU
START RESISTING

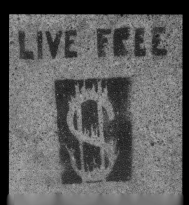

LIVE FREE

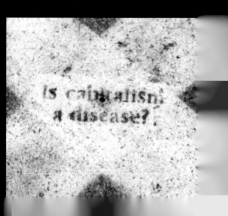

Is capitalism a disease?

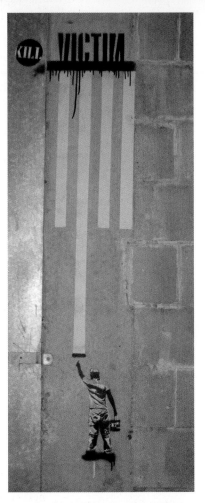

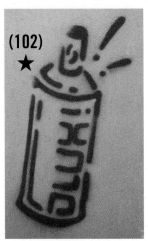

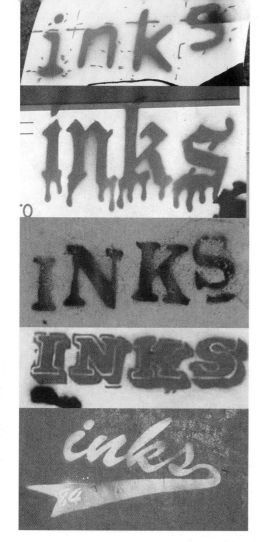

It is fairly recent that the stencil has become an extension of traditional, or "hip hop," graffiti. The politics within traditional graffiti have tended to be extremely raw: alienated and disenfranchised kids getting up and over on the dominant society. While stencils often have either more didactic political or esoteric goals, the core of the traditional graffiti project has always been "getting up," or writing your name as many times in as many places as possible. The face of stenciling has been changing, as now close to half the stencils seen the world over are some version of a graffiti ego marking. Stencils are still a simple combination of an image and text, but the text is no longer some open-ended cryptic message, but instead a name or slogan that defines a specific artist. Stencils are now used to tag territory, the same as greasepens and wide-tip markers.

This shift can be traced to the influence of a number of artists that straddle the two cultures. After graffiti exploded into the art world in the early 1980s, it was quickly passed over for the next trend and left to evolve on its own. New York City also cracked down on and effectively ended the painting of large-scale pieces on trains by the mid-80s, sending most graffiti

(103) ★

GRAFFITI

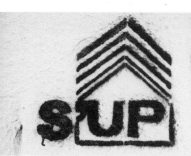
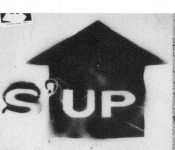

Above left: INKS tags, New York City. Above row, left to right: S'UP tags by Sub∗lin∗gual, Portland OR; RELEKS tag, San Francisco; PEZ sticker, San Francisco. Opposite, top row: Cap by TM Crew; Spraycan, Ann Arbor MI; Spraycan, Chicago; Roller by VICTIM, Melbourne. Second row: Spraycan by DLUX, Melbourne; Spraycan, Santiago; Spraycan by LOTUS, Melbourne. Bottom row: Throw-up by BSPEK, Milwaukee; Pilot Marker by PRISM, Melbourne.

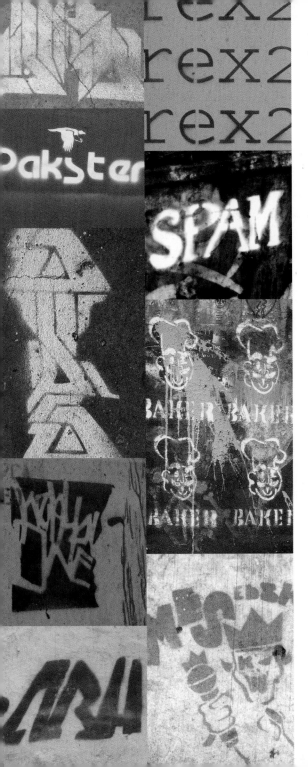

writers back into the world of hit and run tagging on the street. The focus shifted back to creating markings that were only readable by other graffiti writers. Traditional artistic ideas of beauty were replaced by issues of placement, stylistic evolution of basic letter-forms, and most importantly, sheer volume of painting. The artists Cost and Revs took this to an extreme by putting down the spray paint and simply photocopying their names onto millions of sheets of plain white paper and pasting them all over New York. Taking his cue from Cost and Revs, artist Shepard Fairey took this saturation technique to the next level with his "Andre the Giant has a Posse" campaign in which he traveled across the world during most of the 90s putting up millions of images of the wrestler and the word "Obey" via stickers, posters, and stenciling. The sheer coverage of this campaign opened the eyes of traditional graffiti writers driven to write their names in as many places as possible. By utilizing stencils, Fairey helped introduce them as a tool available to graffiti writers. Other stencilers had been doing similar things for years, but none had been so thorough, hard working, or had such a knack for self-promotion.

In 2002, British artist Banksy pushed the stencil into the underground spotlight. The amount of stencils he paints, their increasingly large size, their photographic-looking qualities, and his anti-authoritarian sense of humor have made him the darling of the street art scene and of rebellious kids everywhere. His stencils have been featured in dozens of underground and mainstream magazines. Although his images are compelling and interesting on their own, he follows the logic of traditional graffiti by attaching his name to most of his stencils on the street. Banksy's high name visibility has made it extremely easy for him to be found by the art world and commercial interests. Both Banksy and Fairey quickly jumped into commercial work, with Fairey designing the street advertisement campaigns for bands like Radiohead and Banksy doing record covers for the band Blur. At the same time, Banksy has maintained a street ethic and turned down work from companies

First vertical row, top to bottom, tags by: DISTRS, San Francisco; PAKO, Nashville; DSS, San Francisco; KEPHA, Chicago; ARH, Mexico City. Second row: REX2, Nashville; SPAM, New York City; BAKER, Ann Arbor MI; MES, Chicago

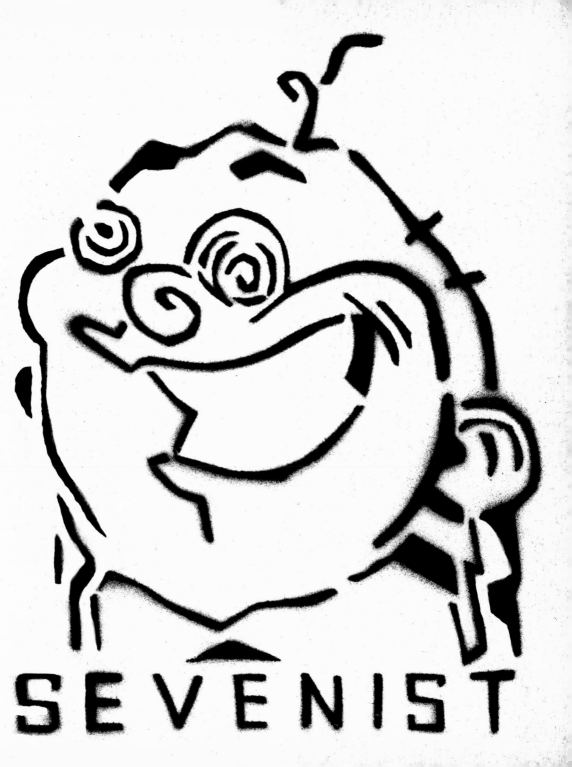

SEVENIST

such as Nike that continually attempt to cloak their cut-throat capitalist business practices with the hipness of the latest street art styles.[40]

With the aesthetics of street art seeing a new wave of popularity and showing up on record covers and in jeans commercials, more and more people are making stencils. Kids that would normally turn to traditional graffiti are stenciling instead, which has led to the influx of graffiti styles into stenciling, primarily in the move towards every stencil having a name attached to it. While having a name attached to a stencil can clearly help boost an artist's identity as well as help an audience connect one stencil to another, it also removes a layer of the playfulness and open-endedness that make non-political stencils so engaging. The influx of graffiti styles has also led to the development of stenciled graffiti characters. Characters are cartoon-like drawings of people or animals that are often unique to an artist. An individual artist will develop a character over years, repainting it over and over again and evolving and changing it in the process.

With the ease of availability to computer technology that can create photo-realistic stencils, there has been an explosion of computers into the culture. This has its pros and cons. On the one side, I fear computers have led the culture of hand drawn and artistic stencils to the edge of extinction. The craft and individual hand that distinguished stenciling is being threatened. While a computer can be used to create an amazing array of imagery, most people only know the most basic functions so computers tend to really limit the scope of work. In stenciling this means high-contrast photo-realistic faces and reproductions of pop-culture objects and icons. Banksy is smart enough to usually turn this on its head, but many others just follow down the well-tread path of movie star faces and pin-up girls. On the other side, computers, particularly the internet, have created a global stencil culture connected by email and websites. Dozens of stencil artists have their own websites that feature photos of their art. Stencilarchive.org hosts an archive of thousands of images from the world over, and sites like stencil-revolution.com provide bulletin boards for artists to trade images, ideas, tips, and information about stenciling. As Russell Howze has stated, "The advent of the internet in the late 1990's has added fuel to the revolution by connecting the international stencil community…. Simple e-mail campaigns urge artists to submit their stencil art to a show on a different continent. Activists create exchange projects where stencils are mailed to other cities for organized public actions."[41] Stencil websites have put artists that were once, by definition, anonymous in direct contact with each other and created a connected culture out of ephemeral markings on the street.

(107)
★

Below, left to right: TIO, Santiago; Elephants by COOP, Melbourne.

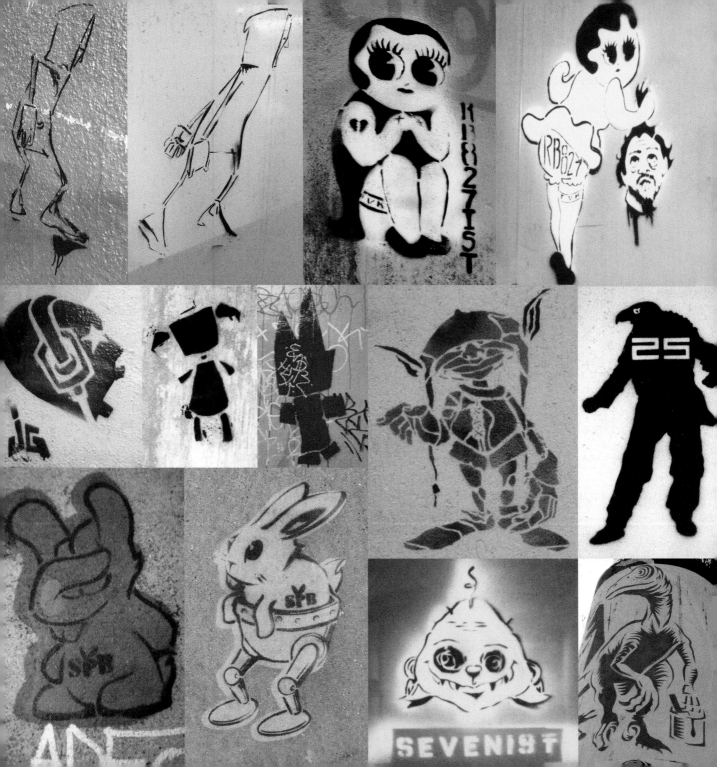

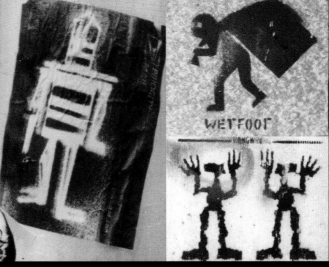
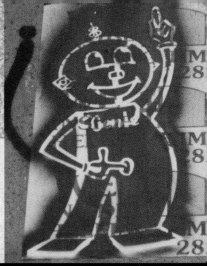

This page, clockwise starting top left: Insinuate by Colin, Ann Arbor MI; Line Figure by Stickman, New York City; Wetfoot by Monkey Wetfoot, Bridgwater UK; Inverted Character, New York City; Troll by Sorciere, Paris; Woman's Head, Perth Australia; Headwrap, Philadelphia; Hi Guy, New York City; Wrestler by KEPHA, Chicago; Two Shadows, New York City; Pointing Character, Melbourne; Dinosaur by 4TRAK, San Francisco. Opposite, clockwise: Hoodie Characters, San Francisco; Girl by RB827, Chicago; Girl with Head by RB827, Milwaukee; 25 by DR. BLADE, Atlanta; Dinosaur by TIKI JAY ONE, Los Angeles; Toothy Character by SEVENIST; Milwaukee; Bunny Characters by Silly Pink Bunny, San Francisco; Head by JG, New York City; Character by Craig, Nashville; Pointy Head Character, San Francisco; Goblin by Sorciere, Paris.

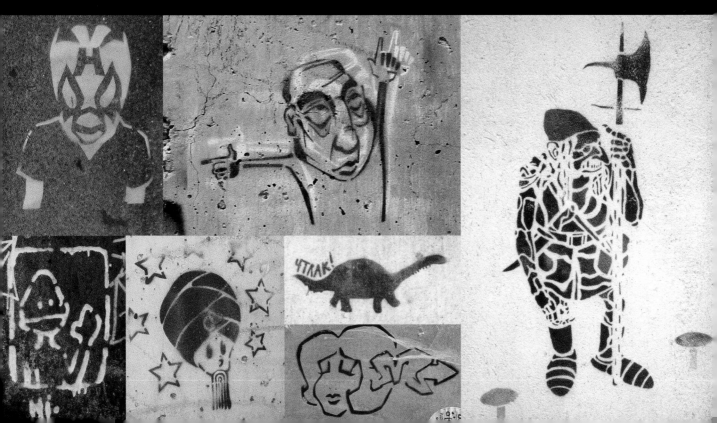

What was once solely a tool used to either attack "the system" or to jog the brains of a tv-medicated public, stencils have now been absorbed into the status quo. They are selling products and promoting identities. Graffiti writers were not the only ones that took notice of the stencils potential to reach huge audiences. Corporate stencils litter the sidewalks of most major cities, especially New York City. And not all the corporate stencils are vulgar ads, they have been creating their own open signs, encouraging head scratching, only to eventually close them with an advertising pitch for a movie or new product. In 2001, IBM launched its own foray into this realm with the "Peace, Love, and Linux" campaign. It paid people to stencil cryptic images of peace signs, hearts, and penguins all over major cities like New York, Chicago, and San Francisco. Eventually it launched print and TV ads that "solved the mystery" of the stencils by using the same imagery to push IBM's Linux software. Some of the biggest users of this guerilla marketing are hip hop clothing lines, internet companies, and the music industry trying to create street cred for their artists.

It could be asked, "Why would corporations use illegal means to spread their message when they have so much money at their disposal to do any kind of advertisement they want?" Well, it is the stencil's illegality that makes it so irresistible. Stencils give products a buzz, they make them hip and seem anti-establishment. Also, corporations have little to lose. In San Francisco and Chicago people were caught painting IBM's Linux stencils, and in both incidents the arrests created pages of press. In

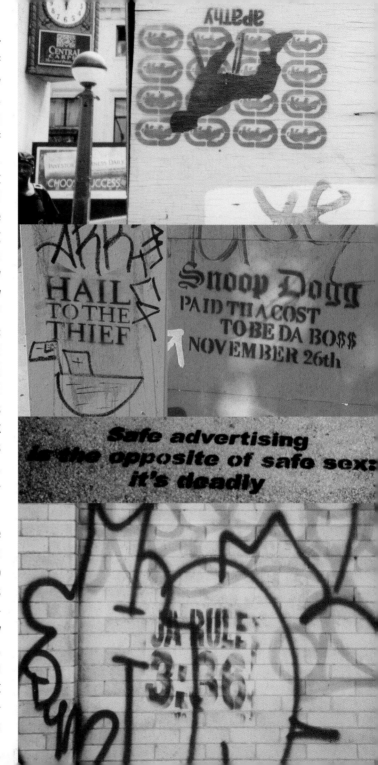

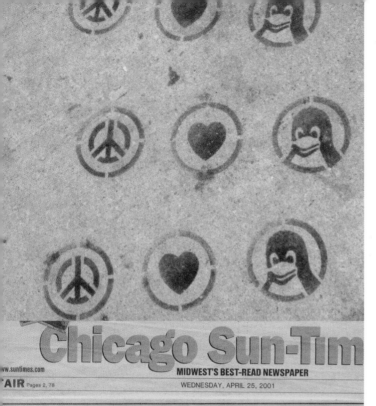

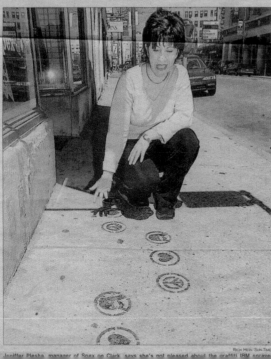

Chicago an image of the stenciled ad ended up on the cover of the Chicago Sun-Times, the city's most read daily paper.[42] This is better exposure for their advertising than money could possibly buy! Just as not all street artists will become recognized, thankfully this kind of guerilla marketing doesn't always succeed. For every Linux campaign that lands front page press and millions at the point of sale, there are dozens of campaigns that involve stencils and street art, like the ones for the Andy Kaufman film biography *Man on the Moon* or another film *Skull and Bones* (whose street campaign involved skull-stamped dollar bills) which failed to generate much interest at box office. Similarly, not all marketing ends up reading as intended. In 1999, the band *Gay Dad* was promoted via a simple stencil of a crosswalk stickfigure with the words "Gay Dad" below it (see page 83). Since the band never made it big, many people who saw it would have mistaken it for a pro-queer parenting message rather than an advertisement.

Although he says "Giant has a Posse has no meaning,"[43] Shepard Fairey couldn't resist the temptation to give capitalist meaning to his art, and now he has built an entire cottage industry selling posters, shirts, hats, and his own design skills with the images and words he once stenciled across the globe. Sure, the words "Obey Giant" have no fixed meaning, but neither do the words "The Gap," "Old Navy," or "Tommygear." Their meaning is given to them in the branding efforts of the company owners. It is a stencil artist's refusal to give this type of meaning to their work that distinguishes them from guerilla marketers. This keeps stencils interesting and leaves their interpretation open to the viewer.

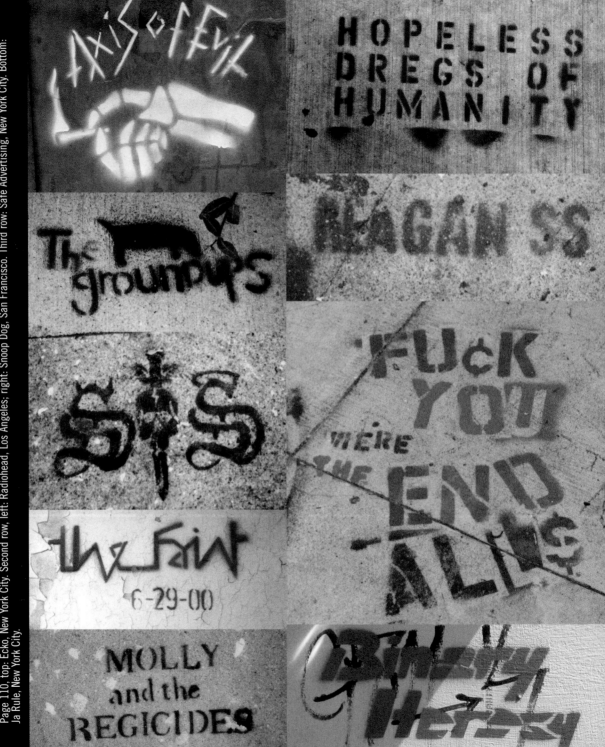

There is one thing that all street stenciling has in common, illegality. Whether you are painting an abstract shape, didactic political statement, or stylized version of your name, you are breaking the law. Property holds ultimate value in society. This creates a strange system of priorities where graffiti abatement programs in most cities spend millions of dollars a year to remove spray paint from walls while thousands of people in these same cities have no food to eat or no place to live. Illegality causes a number of problems for the stencil artist. Carrying stencils without being completely obvious can be difficult, but it has led to an amazing array of creative transportation techniques (see the How-To Files on page 120). It is still true that the harder a city cracks down, the less complicated stencil work you're likely to find. In Chicago, where selling and buying spray paint is illegal and the city has dozens of graffiti removal trucks, there are still stencils, but they tend to be small and simple. In cities like San Francisco and New York stencils are likely to stay up much longer, so artists are often willing to take more risks to paint larger and more complicated works.

There are also benefits to illegality. By painting a street stencil an artist transcends the rules of standard and acceptable behavior. This gives the artist's expression some extra weight. When a person comes across a stencil painted on a bus stop shelter, not only do they read what the stencil says, but they also see that someone has broken the rules to put that stencil there. And unlike some graffiti which is not intended for a random pedestrian to understand, stencils are open to interpretation by anyone, they use the same visual and textual language as everyone else. This gives a stencil a certain level of urgency, a voice that is kept out of the acceptable dialogue, something you aren't supposed to see or hear.

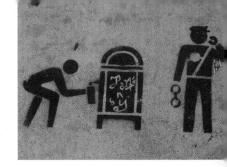

Above: Spraypainter, San Francisco. Below: Religious Pietas, Los Angeles. Bottom row, left to right: Freddie Mckay, Lord Creator, and Mr. Skinhead Reggae by Lord Hao, Paris; Shit Happens by ANT, Vienna Austria.

(115)
★

BEGINNER BASICS

When looking at all the amazing images stencil artists create, it's easy to think that it's a difficult art form to learn. The fact is, it's actually pretty easy. Stenciling is simply spraying paint through a solid material with holes cut in it. Almost every stencil artist I've talked with says they taught themselves how to do it. It's definitely not rocket science, and the more you do it, the better you'll get. These are some ideas and guidelines that can help you out.

IDEAS

The first and most important step in making a stencil is coming up with an idea of what you want to paint. Once you have an idea, and you can use all the images in this book to spark your creativity, you need to draw it out. If you want to use an already existing image, you can either photocopy it or scan it into a computer. No matter what you do, you have to remember that each stencil is only one color, so your image should be solid black on white. A fairly simple, high contrast image is a good one to start with.

You can either draw your image directly onto your stencil material (see Materials below), or you can draw on a piece of paper. If you make your image on paper, you then need to affix it to your stencil material with spray adhesive or a glue stick. For those that don't want to draw, you can take a photograph and make it high contrast on either a photocopier or on a computer. By photocopying an image over and over again with the contrast turned up, you can usually create a black and white image. On a computer you can scan an image into Photoshop and then use filters like "cutout" or the brightness/contrast feature. There are significantly more details for using computers in the tutorial section of stencil-revolution.com.

All illustrations by Emily Forman.

HOW-TO FILE ★

MATERIALS

The material you choose to cut a stencil out of depends on a number of factors, but the most important are use and size. The main use distinction is whether you are going to use a stencil once or try to paint it a thousand times. Stencils you plan on painting once can be made out of just about anything, even regular paper. If I want the stencil to last a little longer I'll use manila file folders. They are both strong and durable but also thin enough to be easy to cut, so a large amount of detail is possible. I use them for all small stencils because you can cut nice, crisp lines and amazingly tight details and they still hold together. Plus, file folders are easily acquired in most office-type settings, as well as copy shops and office supply stores. You can buy something called "stencil board" at art supply stores but it is expensive and doesn't work much different than file folders. Other kinds of cardboard, like chipboard or the material cereal boxes, are made of are much more difficult to cut and aren't as strong as the thinner file folders.

When I want to make a stencil larger than 12"x18" (the size of an unfolded file folder), I usually use regular poster board, the kind they have at most supermarkets and office supply stores. It has the same basic qualities as file folders but its size makes it harder to carry without folding, crushing, etc. It's really important that stencils stay flat so that you can get a clean print, so the bigger they are the trickier it gets to carry and maneuver them. No stencil will last forever, but I have ones that I cut from file folders or poster board that have held up under continued use for years. The paper absorbs some of the paint and becomes more sturdy after it dries, especially if left to dry flat. Some artists use regular corrugated-box cardboard for their stencils, especially extra large ones. I find it difficult to cut, but both RB827 and the Sevenist use this. The Sevenist actually cuts his giant portraits out of old refrigerator boxes (see page 156 and 157).

A large number of artists use plastic materials, either acetate, mylar, or laminated paper. Since it's more difficult to draw directly on the acetate, you can tape it over your drawing and trace the drawing with your knife, cutting out as you go. When laminating, you can laminate your actual design, and just cut that. Although plastics tend to be very easy to cut, I don't like them for two reasons. First, they often crack after only a couple uses, and second, they don't absorb any paint, so after using them once or twice in a night they are completely dripping and make really messy prints. Some artists swear by acetate, but I've never had any luck with it. Last but not least I've heard of artists cutting stencils out of thin flat magnetic material, like the kind that promotional refrigerator magnets are made out of. This seems like a great idea if you plan on painting on metal, since the stencil will stick without having to tape it or hold it up. With some practice and experimentation everyone finds the materials they like to use best.

Any kind of knife, blade, or even scissors, can be used to cut stencils. Some people like big box cutting blades but I find them heavy and unwieldy. I cut everything with exacto-type knives; nothing special, just the regular size knives and the regular blades. I find these knives the easiest to use; I hold mine almost like I would a pencil, and they have a really tight cutting radius so its pretty easy to cut really small details with a little practice. The blades break extremely easily, so you might want to get a box of replacement blades. If you are using acetate or mylar for your stencils, there are stencil cutting tools you can get at most hobby shops. These are basically little heat guns with a metal tip, and you use the tip to actually melt through the acetate. I've heard these work well from Stain and Scout, but since I don't use plastics for my stencils, I haven't tried it.

PAINT

The most important thing I've learned about paint is that you get what you pay for (that is if you actually buy paint). Cheap cans of paint are inexpensive, but you won't get as much paint out of them and the paint is low quality and doesn't survive the elements very well. Also, the airtight seal on the can that holds the paint and propellant in is really low quality, leading to frequent clogs, which make a mess and sometimes even make the can unusable. So, given that laundry list, I usually stick to higher quality paint, either Krylon or Rust-oleum, and their sub-brands: Color Works and Painters' Touch or American Accents respectively. American Accents, in particular, has a wide range of colors. These sub-brands are usually half the price and are almost as good. There are also a number of spray paint brands from Europe, like Montana and Belton, that are great paints, but usually can only be mail-ordered here in the U.S. and are very expensive. Another really important piece of information about paint is that you always want to use flat, ultra-flat, or satin paints. They dry significantly faster on the street and on your stencil and it is easier to lay a second color on top of them.

Unlike traditional graffiti, the nozzles on the paint cans, often called "caps," aren't quite as important for stenciling. What are called "fat caps," or anything that will widen your spray area, can be useful because they mean less time standing with a can in your hand. I've also found that the large industrial cans of paint made for job sites ("upside-down cans") sometimes have caps on them that fit onto regular cans and create a nice fan-like wide spray which is great for stencils. Also, even if the caps aren't interchangeable, if you are primarily painting on the ground it might be worth just using an upside-down can, they hold a lot of paint which usually comes out clean and fast. If you're feeling adventurous you can usually order all different kinds of caps through most graffiti magazines or websites.

GOING OUT

One of the biggest problems with stencils is that you have to carry them around and somehow still not look like your causing trouble. There are literally hundreds of techniques to carry stencils that people use. I'll list a handful:

• Probably the easiest way to carry a small stencil is just sliding it into a folder or newspaper. The problem with this technique is that once it's wet it'll stick, which can cause a mess.

• Some people like to carry stencils in old backpacks and other bags, I've always found that pretty messy.

• For bigger stencils, I've lined a cardboard artist portfolio with chicken wire. You just look like an artist and the wire keeps the stencils from sticking to the cardboard (a smaller version of this can be made for putting in a folded newspapers -see above).

• You can cut the bottom out of a large brown paper shopping bag and tape your stencil in its place. It just looks like you're carrying home the groceries, but you can set the bag down, reach in and spray.

• People have replaced the bottom of a pizza box with a stencil, or the bottom of just about any box for that matter. Be careful, though, a friend tried this pizza box technique in area that was a popular hang out for college students and had to fend off drunk frat boys demanding a slice of pizza!

• Mini-vans are great vehicles for stenciling. They can easily carry extra-large stencils, make great cover to stand behind while painting and have the added value of looking like a "wholesome" family vehicle. Sometimes you can slide the side door open and paint without even getting out. When you are out on the street, picking good locations to paint your stencil is also very important, see page 126 for more info on placement.

HOW-TO FILE ★

SAFETY

Safety is important in two very different ways. First, street stenciling is illegal. Second, spraypaint is extremely toxic and bad for your health. As for illegality, you shouldn't stencil unless you feel justified breaking the law and are willing to take the risks. If you are going to paint, the initial step is wearing clothes that you are comfortable in. Common sense would lead you to wear all black, but often that's not the best choice. Sometimes you can blend in better being a little dressed up and conforming to stereotypes, like a shirt and tie for men, dress or skirt for women. Graffiti writers have been known to dress in business attire, various work uniforms, like homeless people, you name it, it's been tried. The bottom line is that you need to feel comfortable painting, so you should wear what works for you.

Some people like to paint alone, but I would suggest always using a lookout. Some go out in larger teams. Really simple codes for "it's ok to paint" and "stop!" can be developed. I have friends in San Francisco that even use walkie talkies to communicate and avoid arrest. Stenciling used to be a lot more simple, when the cops drive by, you stop. The problem is, now that everyone has cellphones, everyone is a potential cop. In addition, in cities like New York, I've seen police drive around in taxis and other vehicles. Another very basic piece of advice is don't paint on the same street for long periods of time. Cut down on side streets, cover lots of ground, and don't hang around the same areas for too long. Zigging and zagging will ensure that you don't leave a straight and simple trail behind you. There are also ongoing debates on what is appropriate to paint on and what isn't. Every artist needs to assess their location, but general courtesy rules say don't paint on private residences or mom and pop stores. Advertisements, boarded-up buildings, corporate buildings, and political targets (i.e. a government building or a

consulate where a protest will be held) are places most people will paint.

There are two schools when it comes to getting caught, either you run or you don't. If you run, you need to be prepared for the consequences. Running definitely increases the chances you'll get away, but also increases the chances you'll fall and get hurt (many people have broken legs falling off embankments or roofs). Also, if cops have to chase you, they definitely won't be happy. It boosts the chances they will show up in court to ensure you are found guilty, and in some cases boosts the chances they beat you up when they catch you (which recently happened to my friends Gloe and User). The other school is taking the hit, which could lead to being let go or getting arrested and booked, it depends on the city and the specific cops. Each city has its own system to deal with arrested graffiti writers, so you should investigate your location if you want to know the consequences of getting caught.

On the other end of safety, spraypaint is deadly, plain and simple. It contains a number of chemicals, including xylene, which are extremely harmful to your kidneys, nervous system, and other sensitive body parts. Whenever possible a respirator should be worn when using spraypaint. Not the flimsy white painting masks, but a full respirator. Also, rubber or latex gloves should always be worn. The chemicals in spraypaint don't just enter through your mouth and nose, but are absorbed through the skin, eyes, and ears. It is fairly common for older graffiti writers to have minor nervous disorders or bladder trouble, some have gotten seriously ill. It's always best to take precautions before it's too late!

These are all just basic ideas and suggestions. Everyone needs to figure out what works for them, and the only way to know that is to get out and try.

HOW-TO FILE ★

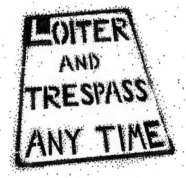

we must

EMPOWER each other...

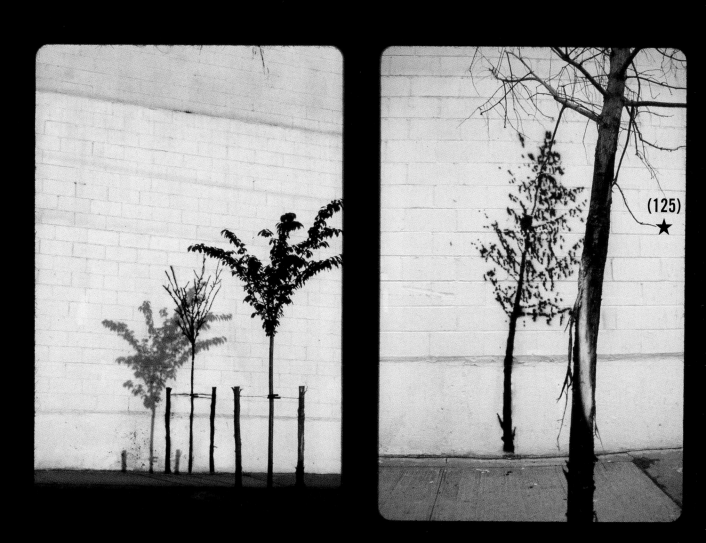

(125)
★

PLACEMENT

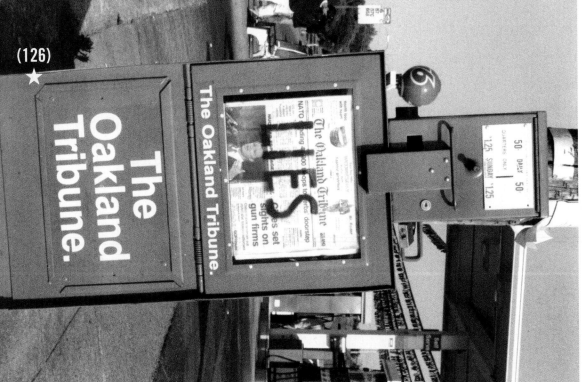

Above: Lies, Oakland.
Opposite, clockwise from top left: Stop Spending Money Asshole by CRASH, Ann Arbor MI; Toxicity, Santiago Chile; Workhorse Face by Logan Hicks, Los Angeles; Andre the Giant by Shepard Fairey, Boston; Surfer, Vienna Austria.
Page 125: Tree Shadows by Jeff Stark, Brooklyn.

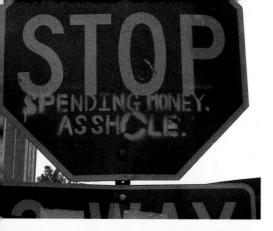

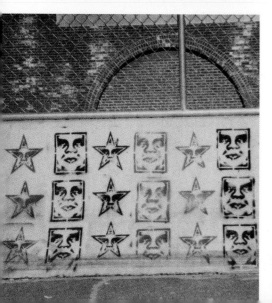

ocation is everything. Well, not everything, but it's pretty important for any piece with content that only fulfills its meaning in a specific place, like stenciling "LIES" on a newspaper box, or Jeff Stark's tree shadow stencils (page 125) that are designed to only be painted right behind the tree they are drawn from. Any stencil with an aesthetic that demands a certain size or amount of space also demands good placement. I've lost track of the number of stencils I've seen that would look great other than the fact that they are dwarfed by their surroundings. Since it's difficult to carry around large-scale stencils, artists have developed some basic techniques to make the most of small-scale images. One is to paint in small, framed spaces or on small panels (see Workhorse image below). The best examples of this are the boxes that sit at the bottom of street lamps. They exist in almost all middle to large size cities in the U.S. and are of a fairly uniform size. In New York City alone hundreds of these boxes have been stenciled, and it's pretty easy to find them painted in Boston, Chicago, and Philadelphia. Another trick is to paint large grids of repetitive images. Other common locations for site-specific stencils are stop signs, which are standardized and have a strong preexisting meaning that can be used to help get a message across, and framed doorways, which are perfect for stenciling life size figures.

(127)
★

TOXICITY TOXICITY

LAMP POST BOXES

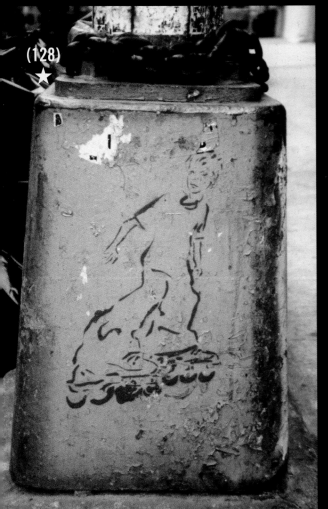

Left: Rollerblader, New York City. Top row left to right: Shape by Kelly Burns, New York City; Raised Fist, New York City; BUCS, New York City; Giant by Shepard Fairey, New York City; Gorilla, New York City; Cap, Boston; No War, New York City. Middle row: Face, New York City; BAST, New York City; Giant Star by Shepard Fairey, New York City; Radiohead Character, New York City; COP, New York City; Pi Movie Promo,

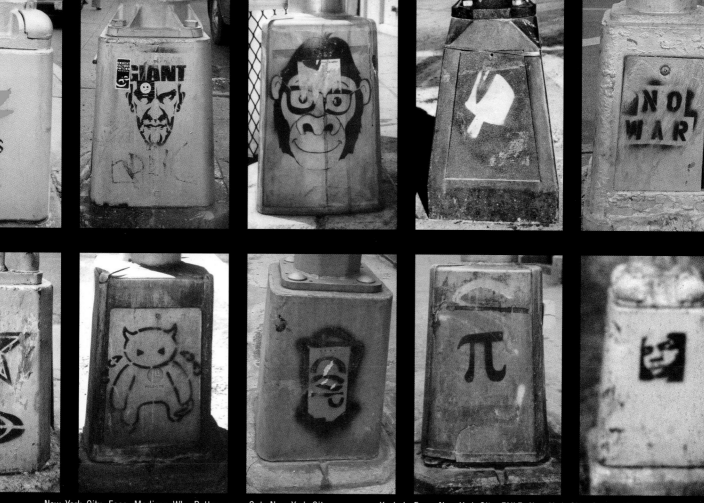

New York City; Face, Madison WI. Bottom row: Cat, New York City; Bomb, New York City; PORK, New York City; Y2K, New York City; Cage by Josh MacPhee, Chicago; Face, New York City; Free Gas, New York City. Next two pages, top row left to right: Auto Free, New York City; Bill Murray, New York City; JEST, NYC; Spock by ADORN, New York City; Keyhole Face, New York City; FAILE, New York City; Crown, NYC; Free Mumia, Brooklyn. Bottom Row: Face by Book Wars, New York City; Zapatista, Mexico City; Giant by Shepard Fairey, Philadelphia; Hip Hop by J, New York City; Pill by JSO4, Chicago.

(130)
★

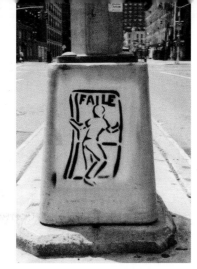

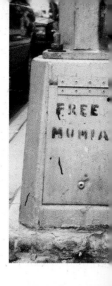

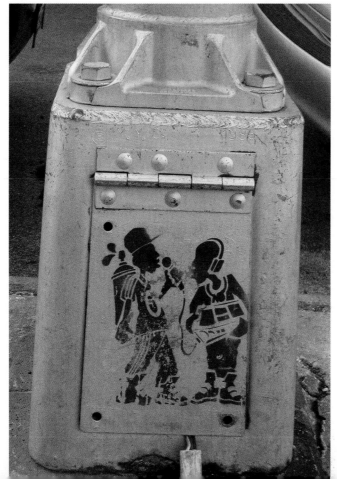

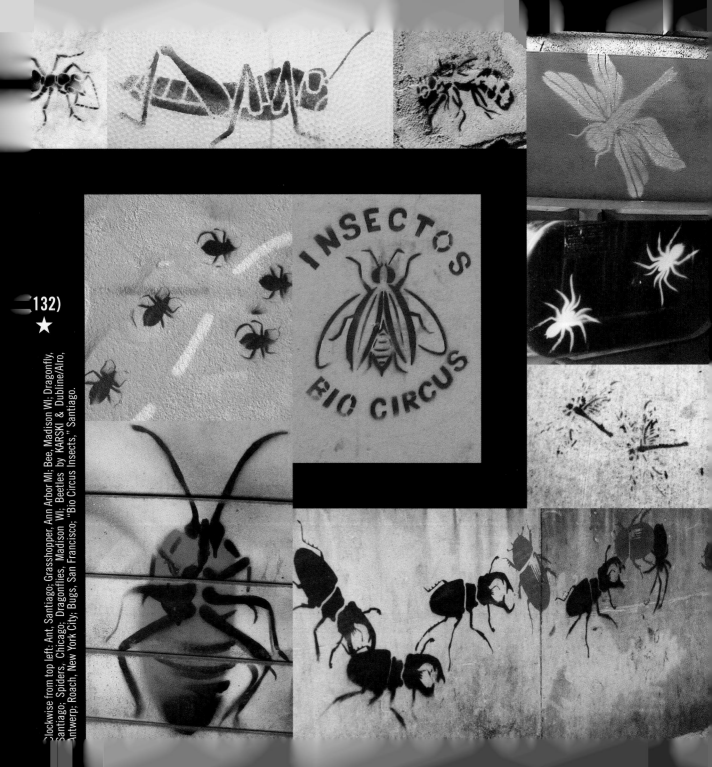

Clockwise from top left: Ant, Santiago; Grasshopper, Ann Arbor MI; Bee, Madison WI; Dragonfly, Santiago; Spiders, Chicago; Dragonflies, Madison WI; Beetles by KARSKI & Dubline/Alro, Antwerp; Roach, New York City; Bugs, San Francisco; "Bio Circus Insects," Santiago.

Clockwise from top below: Deer by Scott Williams, San Francisco; Giraffe by Peat Wollaeger, St. Louis; Rats, Philadelphia; Squirrel by TeeTee, Linköping Sweden; Snake by James S., San Francisco; Party Rats by BANKSY, Melbourne; Ass, San Francisco; Frog, Melbourne; Pig, New York City; Cow, San Francisco.

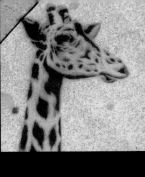
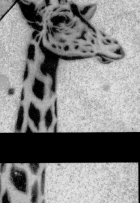

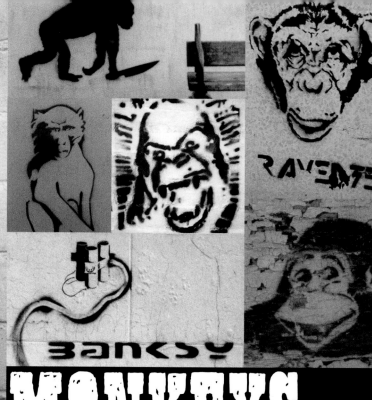

why did the monkey fall out of the tree?

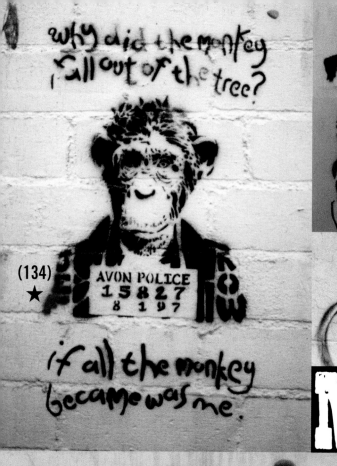

AVON POLICE
15827
8 1 97

if all the monkey became was me.

BANKSY

MONKEYS

PEACE TO YOU ALL.

MONKEY

Clockwise from top left: Jailed Monkey by Jefrow, Bristol; Monkey with Knife by RAVEN75, Nicosia Cyprus; Chimp by RAVEN75, Nicosia Cyprus; Ben Davis Ape by James S., San Francisco; TNT Monkey by BANKSY, Bristol: Monkey Stickers by MONKEY WETFOOT, London; Three Apes, Buenos Aires; Baboon by James S., San Francisco; Angry Ape by STUMBLE, Melbourne.

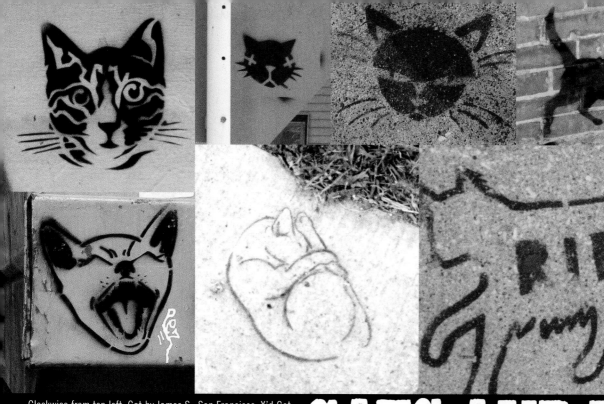

Clockwise from top left: Cat by James S., San Francisco; X'd Cat, Chicago; Cat, San Francisco; Cat Shadow, Montreal; RIP Cat, Chicago; TNT St. Bernard by RAVEN75, Nicosia Cyprus; Boston Terrier by Peat Wollaeger, St. Louis; Dog, Louisville; Slush Puppy by James S., San Francisco, Meowing Cat, San Francisco; Sleeping Cat by Mike Luckett, Nashville; Bulldog by WITH/REMOTE, St. Paul.

CATS AND DOGS

(135)

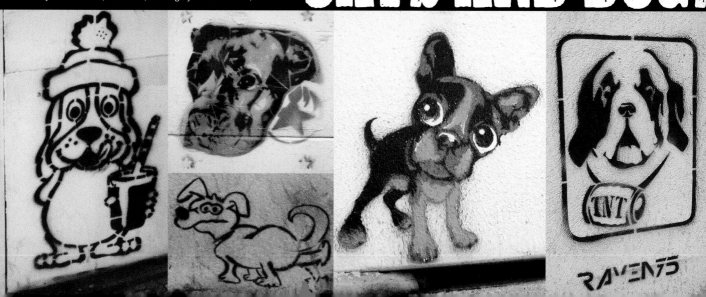

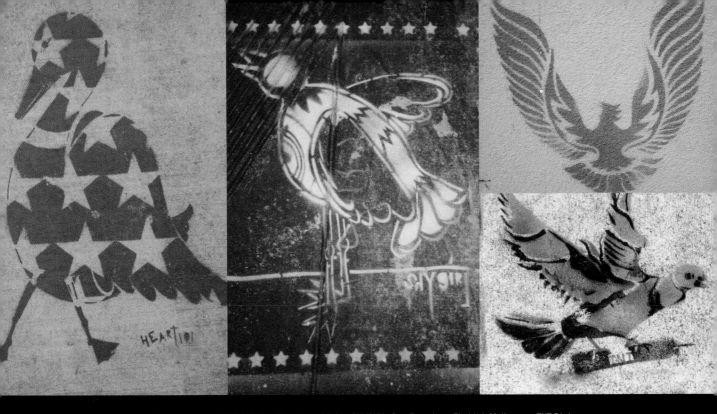

Above, left to right, top to bottom: Star Goose by HEART 101, San Francisco; Bird by SHYGIRL, San Francisco; Firebird, Melbourne; TNT Bird, San Francisco; Bird by Iggy, San Francisco; Bird, San Francisco; Hummingbird by GIDEON, Ann Arbor MI; Stork, San Francisco. Below: Inverse Bird, Boston; Birds by Jeff Stark, Pittsburgh; Little Bird, San Francisco; Pigeons by Jeff Stark, Brooklyn; Zoom Bird, San Francisco; SOS Bird, San Francisco; Chicken by TEMPER, Athens Greece; Fuck Bird by HEART 101 & SHYGIRL, San Francisco.

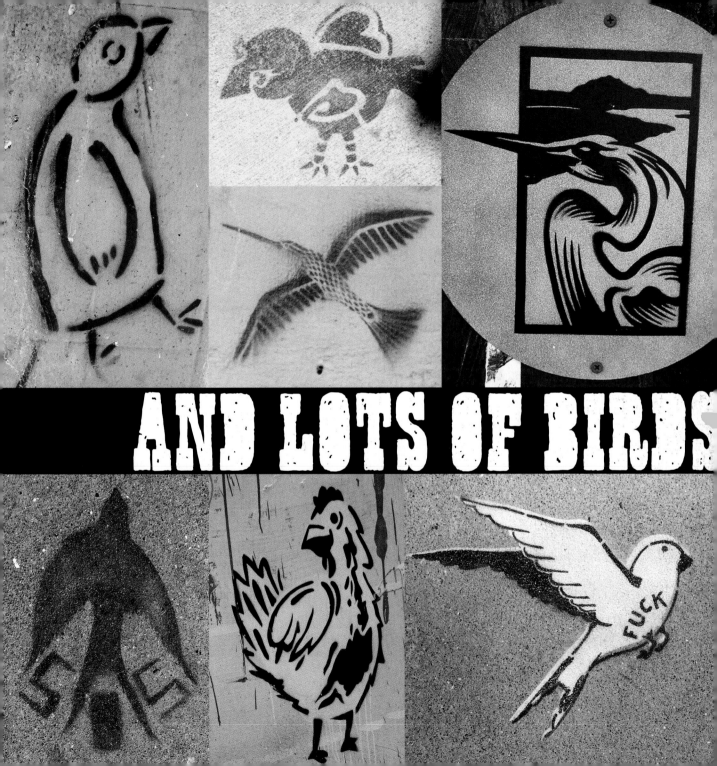

AND LOTS OF BIRDS

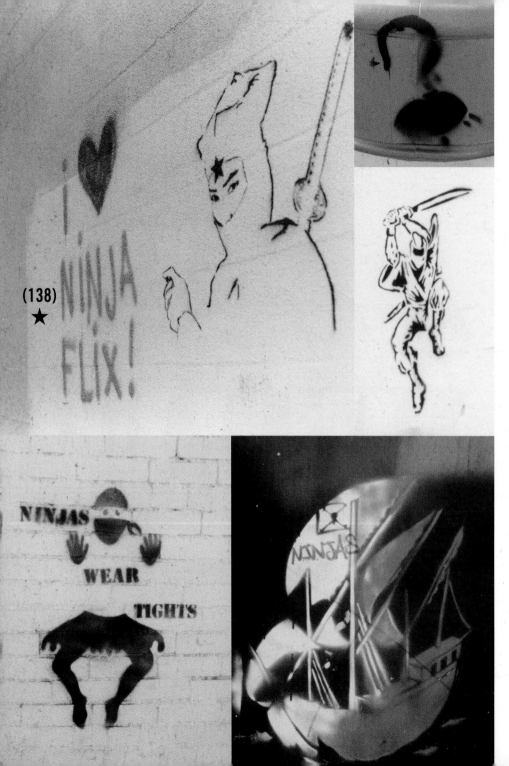

In Nashville Tennessee artists have organized a giant ongoing stencil game. They've created two teams, the Ninjas and the Pirates, and have blanketed the city with stencils referencing their team namesakes. The game started with simple small stencils of ninjas and pirates cropping up around town, but soon life-size ninja stencils were being painted on the walls of places that "pirates" worked and pirate skulls were painted on the cars of "ninjas."

No one was ever declared a winner and active participation in the game still ebbs and flows today. Next time you visit Nashville keep an eye out for stencils of parachuting peg-legged pirates and ninja swords slashing through the Jolly Roger.

All stencils in Nashville by Ninjas and Pirates respectively.

1. Cut along dotted line 2. Cut out black sections 3. Hold against flat surface 4. Spray paint through cut stencil

FORGET THE GROCERY STORE:
LEARN ABOUT EDIBLE

Wild Plants

Above: All three stencils on advertisements in San Francisco. Below, top: Corn and Cogs by Shaun S., Nashville. Bottom: Rad Log, San Francisco.

Over thousands of years the basic mechanics of stenciling have stayed the same; stenciling is an extremely rudimentary printing process. That said, ever since the beginning artists have been pushing and stretching those boundaries and limitations. Today, stencils are getting bigger and more complicated. Around the world, artists are experimenting with stencils taller than ten feet and longer than twenty, with multiple colors and layers. As stenciling has become more integral to the larger movement of street art and graffiti, it has fused and merged with other forms including freehand graffiti, wheat-pasted posters, stickers, and other street installation processes.

From humble origins as territory markings and government signage, street stenciling has become a global art movement with ever expanding purposes, goals, and participation. As a result of the internet, we now have the beginnings of a global stenciling community. Not only can artists communicate with each other and share photos of their work, but templates can easily be emailed back and forth. Now artists halfway across the planet from each other can quickly and easily be cutting and painting the same stencil on their respective city streets.

There is no question that corporations are fighting to control every square inch of our visual landscape. It has become increasingly difficult for individuals and groups outside of institutions and corporations to get their ideas, beliefs, and aesthetics into the public eye. Stencils have long been an integral tool for artists attempting to combat that hegemony, and it looks like they will continue to be

(141)
★

TRANSPORTATION

(143)
★

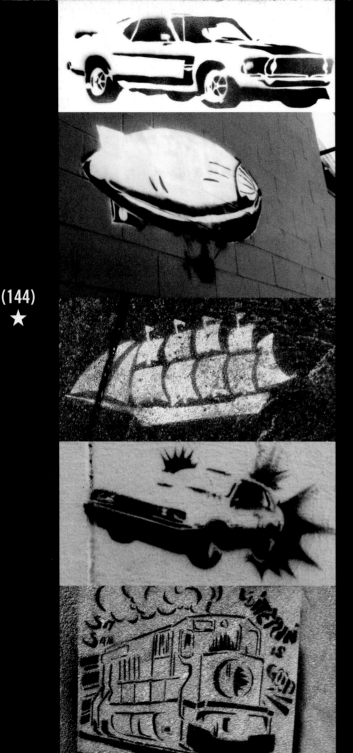

(144)
★

To the left, top to bottom: Stinger by J-F Fury, Melbourne; Blimp by Shaun S. & W.C. Stewart, Nashville; Boat, San Francisco; Sports Car by Shaun S., Nashville; Loiterin' is Good Train by ALONE, Chicago.

Pages 142 & 143: Boredom Bus, San Francisco

Page 145, top row left to right: Old Car by RONE2, Melbourne; Delivery Truck by SHIRO, Santa Monica; Car with Camper by ALONE, Chicago. Below: Model Airplanes, San Francisco.

Page 146, clockwise from top left: Police Van by 8-BIT, Stoke On Trent UK; Police Car by HA-HA, Melbourne; Lincoln Town Car by Ben, San Francisco; Dump Trucks by WITH/REMOTE, St. Paul MN.

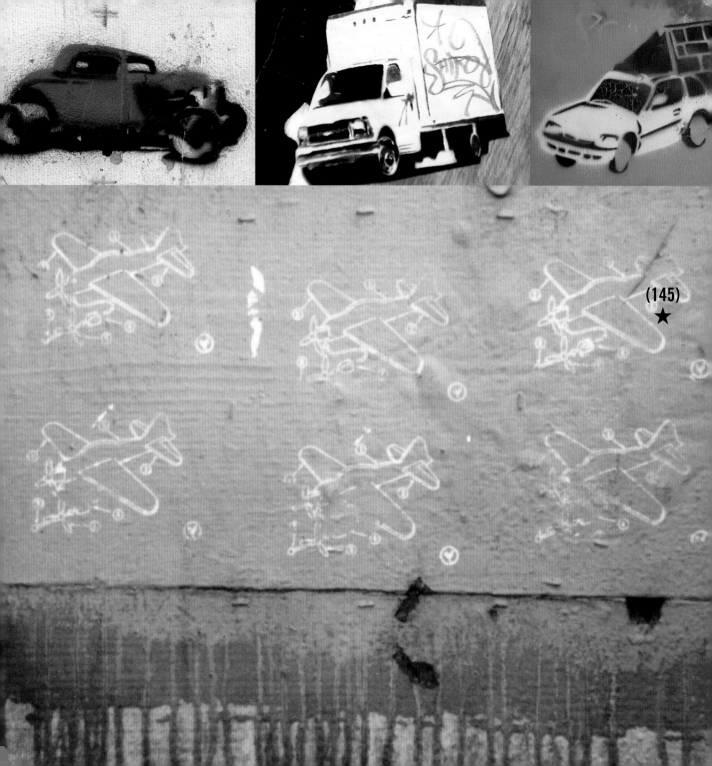

(145)
★

(146)
★

(147)
★

Above, left to right: Bike and Flowers, San Francisco, Bike Trash Can by Shaun S., Nashville; Trashcan with Face by W.C. Stewart, Nashville. Below: Stencil Wall by BSASTNCL, Buenos Aires.

(148)

★

Pages 148-151: Stencil Covered Canada Lane in Melbourne.

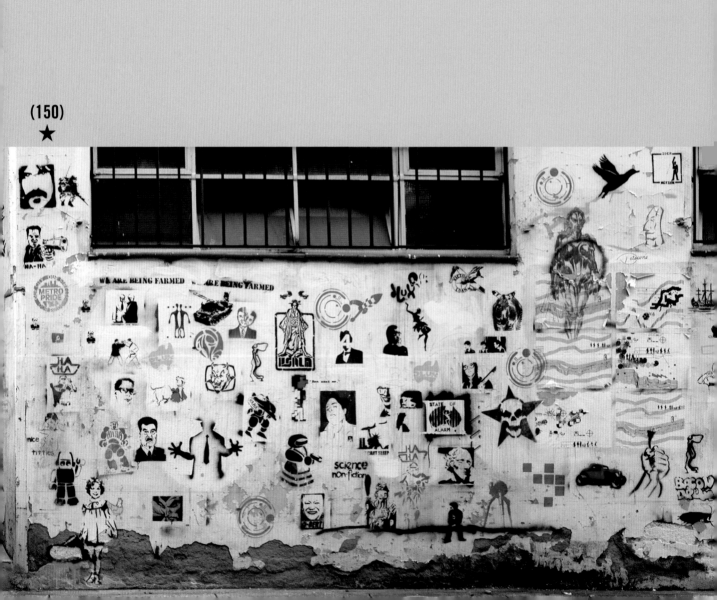

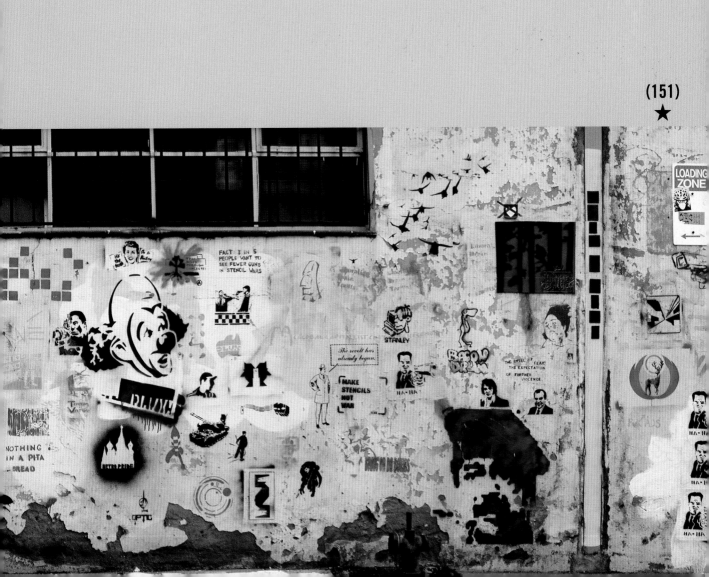

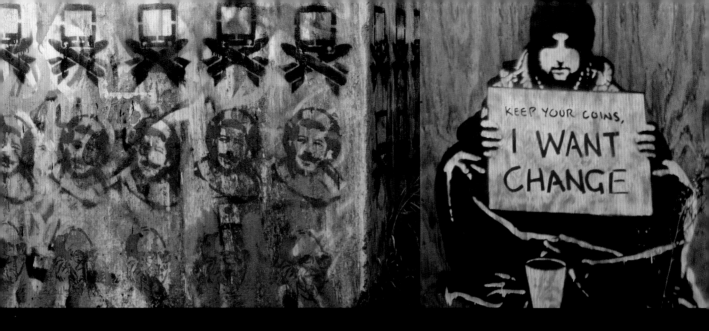

Above, left to right: Stenciled Wall by Gerardo Yepiz, Ensenada Mexico; I Want Change by MEEK, Melbourne; Gomer Pyle Heads by WITH/REMOTE, Minneapolis MN; Be Brave! by Shaun S., Nashville. Below: Are We Free Yet? by JS04 and SEVENIST, Chicago.

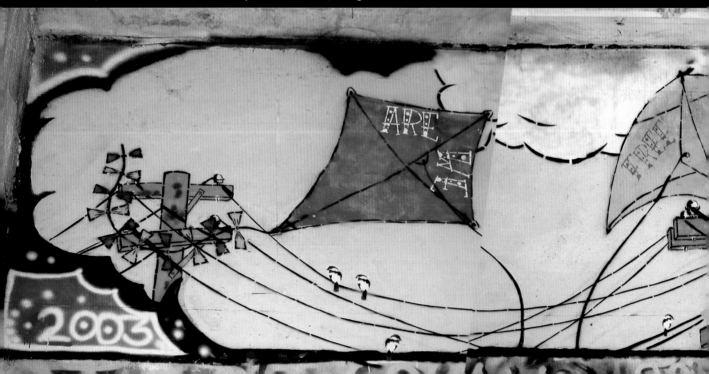

...be brave!

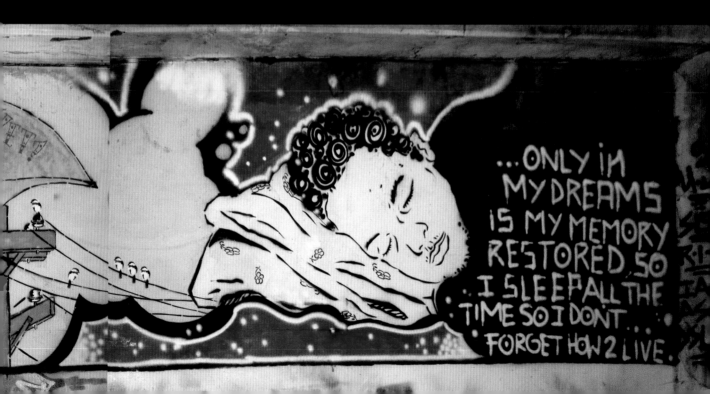

...ONLY IN MY DREAMS IS MY MEMORY RESTORED SO I SLEEP ALL THE TIME SO I DONT... FORGET HOW 2 LIVE.

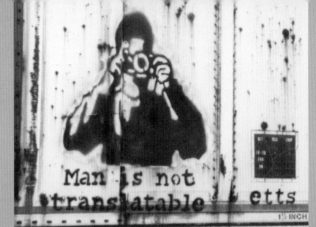

To the left: Man is Not Translatable by ETTS, Milwaukee. Below: Figures by SWOON, New York City.
Opposite, clockwise from top left: Invisible Inc., New York City; Face by Eyeformation, Lowell MA; "The Art Lies to Me" by MISS-TIC, Paris; Fight The Power by Ignorancia, Madrid.

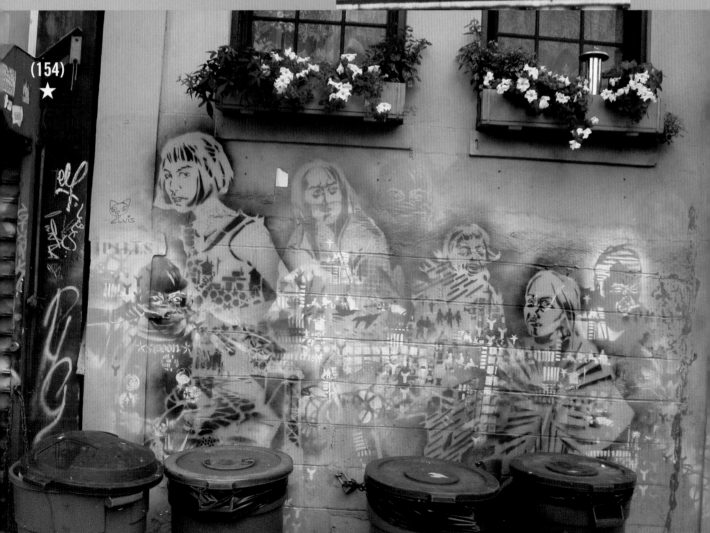

(154)

INVISIB
Inc.

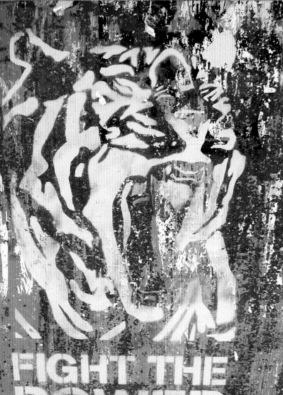

FIGHT THE
POWER

L'ART
ME
MENT

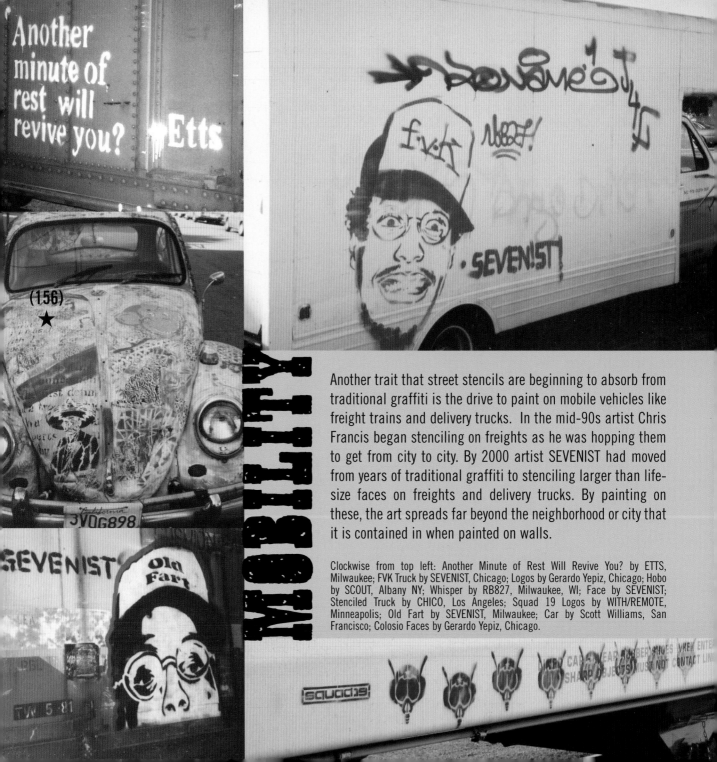

Another minute of rest will revive you? ▼Etts

(156) ★

fvk NBQE!

. SEVENIST!

SEVENIST Old Fart

TVK 5-81

MOBILITY

Another trait that street stencils are beginning to absorb from traditional graffiti is the drive to paint on mobile vehicles like freight trains and delivery trucks. In the mid-90s artist Chris Francis began stenciling on freights as he was hopping them to get from city to city. By 2000 artist SEVENIST had moved from years of traditional graffiti to stenciling larger than life-size faces on freights and delivery trucks. By painting on these, the art spreads far beyond the neighborhood or city that it is contained in when painted on walls.

Clockwise from top left: Another Minute of Rest Will Revive You? by ETTS, Milwaukee; FVK Truck by SEVENIST, Chicago; Logos by Gerardo Yepiz, Chicago; Hobo by SCOUT, Albany NY; Whisper by RB827, Milwaukee, WI; Face by SEVENIST; Stenciled Truck by CHICO, Los Angeles; Squad 19 Logos by WITH/REMOTE, Minneapolis; Old Fart by SEVENIST, Milwaukee; Car by Scott Williams, San Francisco; Colosio Faces by Gerardo Yepiz, Chicago.

squad19

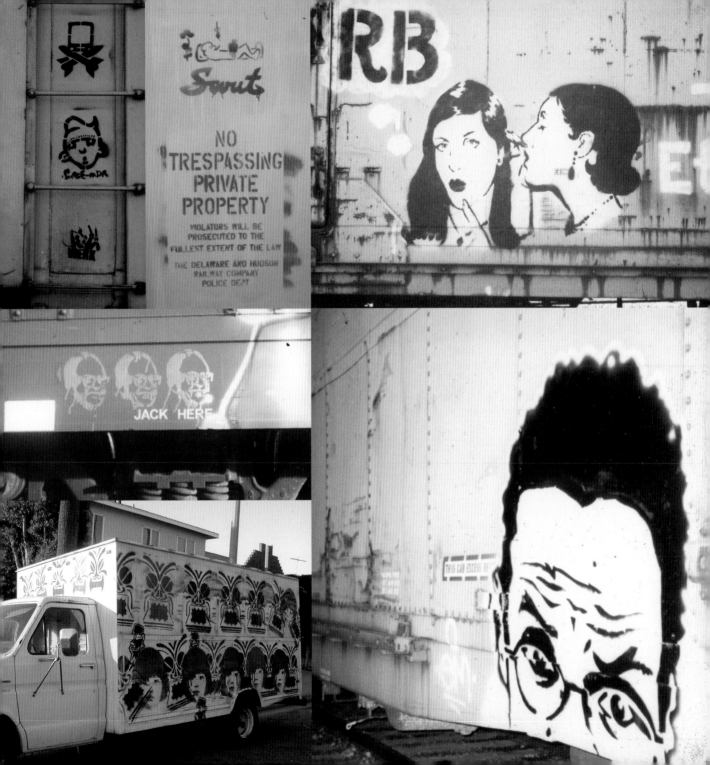

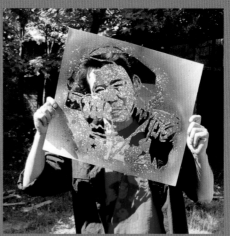

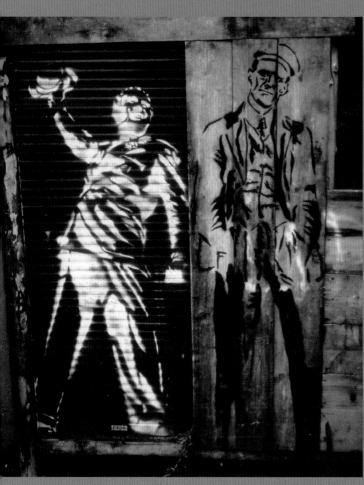

Clockwise from top left: Girl by SIXTEN & Tank Head by BANKSY, Melbourne; Spliff Gachette holding up a stencil, Paris; Kid with Boombox by SYN, Melbourne; Life-Size Men by Epsylon Point, Paris.

Clockwise from top center: Virgin by Peat Wollaeger, St. Louis; Microsoft Nazis, Barcelona; Follow Your Leaders by David Wilcox, Toronto; Angel by RAVEN75, Nicosia Cyprus; The Faithful Breakman by SCOUT & STAIN, Albany NY; Kid Spray Painting by Jeff Stark, New York City.

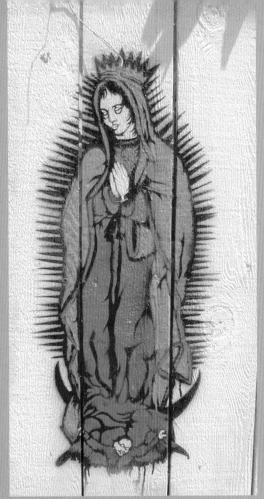

(159)
★

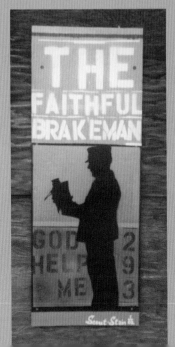

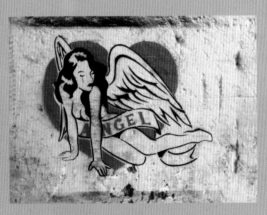

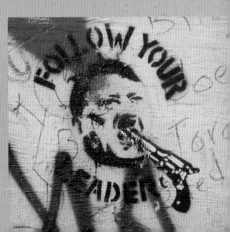

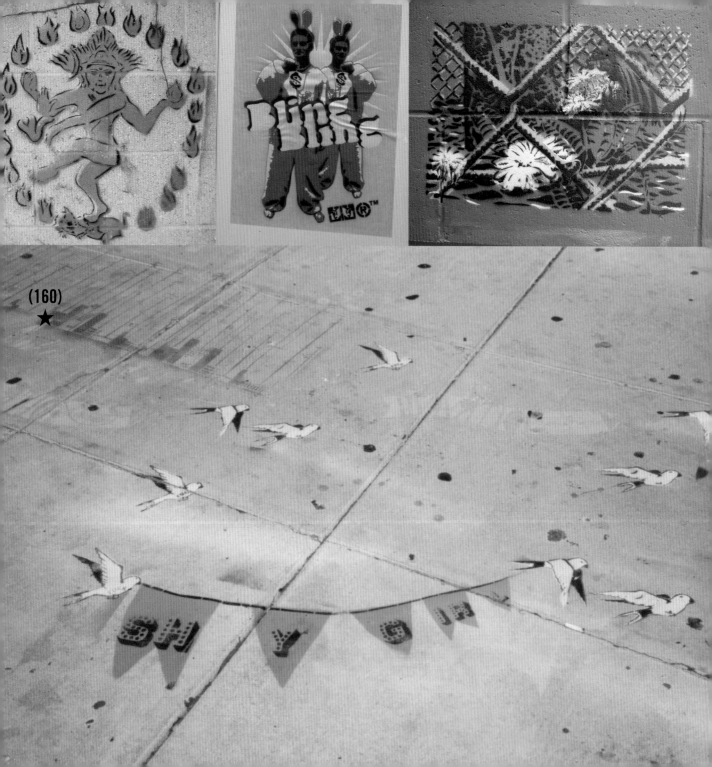

(160)
★

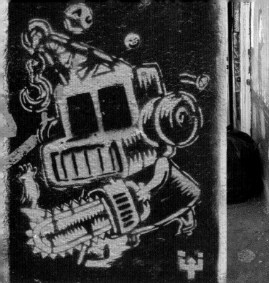

SPEED CRAZY

"COME ON — IT'S JUST A FUCKING STENCIL"

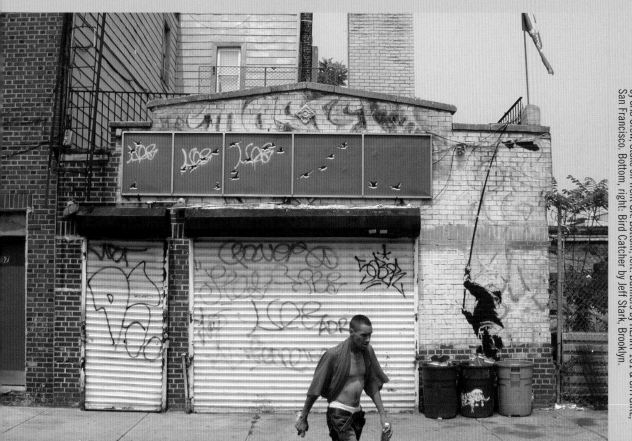

Top row, from far left: Shiva by Lannie, Bloomington IN; Bling Bling by WITH/REMOTE, St. Paul; Fence Scene, Bloomington IN; Girl Machine, Barcelona; Phone Booth, New York City; It's Just a Fucking Stencil, Melbourne; Weird Marilyn by SAS Crew, Stoke on Trent UK. Bottom, left: Banners by HEART 101 & SHYGIRL, San Francisco. Bottom, right: Bird Catcher by Jeff Stark, Brooklyn.

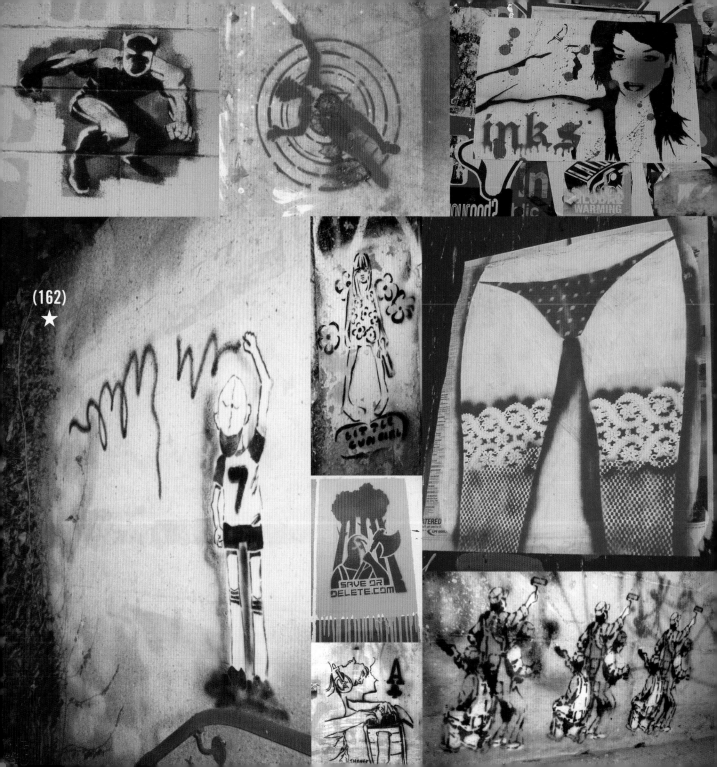

(162)

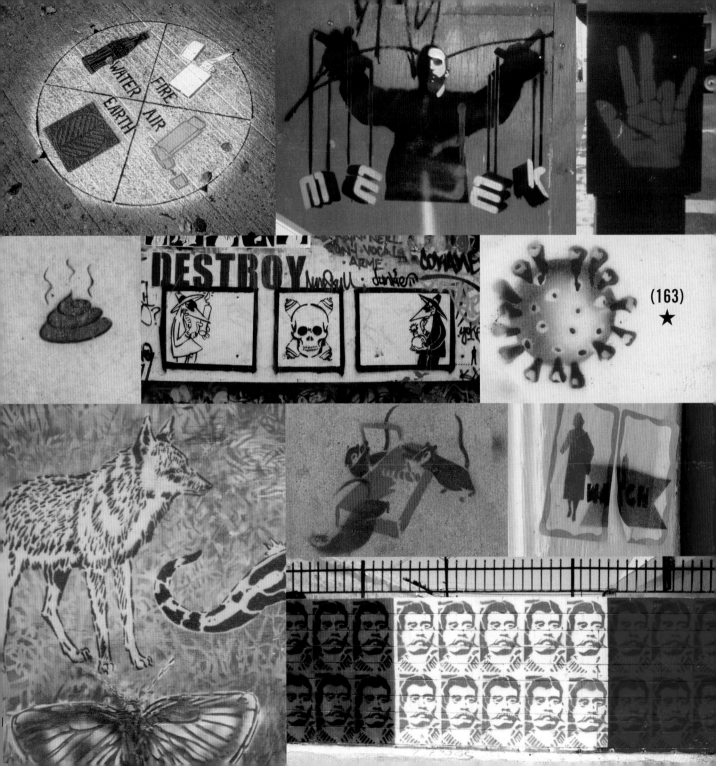

(163)
★

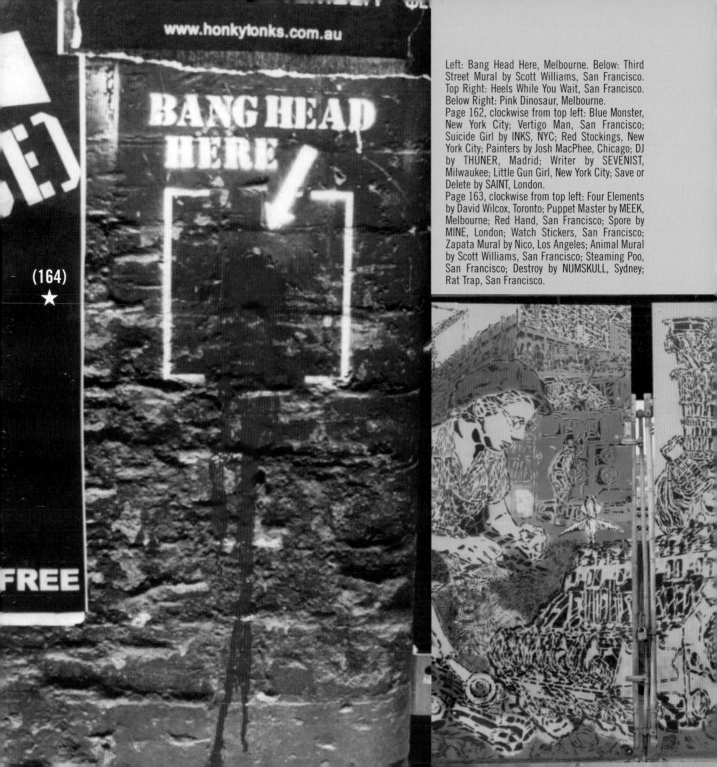

www.honkytonks.com.au

BANG HEAD HERE

FREE

Left: Bang Head Here, Melbourne. Below: Third Street Mural by Scott Williams, San Francisco. Top Right: Heels While You Wait, San Francisco. Below Right: Pink Dinosaur, Melbourne.
Page 162, clockwise from top left: Blue Monster, New York City; Vertigo Man, San Francisco; Suicide Girl by INKS, NYC; Red Stockings, New York City; Painters by Josh MacPhee, Chicago; DJ by THUNER, Madrid; Writer by SEVENIST, Milwaukee; Little Gun Girl, New York City; Save or Delete by SAINT, London.
Page 163, clockwise from top left: Four Elements by David Wilcox, Toronto; Puppet Master by MEEK, Melbourne; Red Hand, San Francisco; Spore by MINE, London; Watch Stickers, San Francisco; Zapata Mural by Nico, Los Angeles; Animal Mural by Scott Williams, San Francisco; Steaming Poo, San Francisco; Destroy by NUMSKULL, Sydney; Rat Trap, San Francisco.

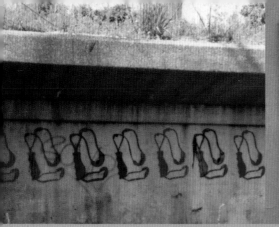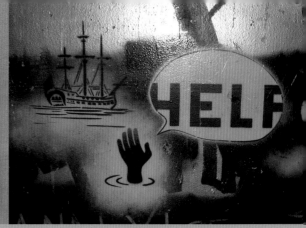

(166)
★

Top row: Slingshots by Josh MacPhee, Chicago; Face Installation by Eyeformation, Lowell MA; Help by CIVIL, Melbourne; Have You Looked Up Lately? by SHYGIRL and HEART 101, San Francisco.
Bottom Row: Chequebook Vandalism by BANKSY, London; Meta Surfer, San Francisco; Two-Headed Girl by RB827, Milwaukee.

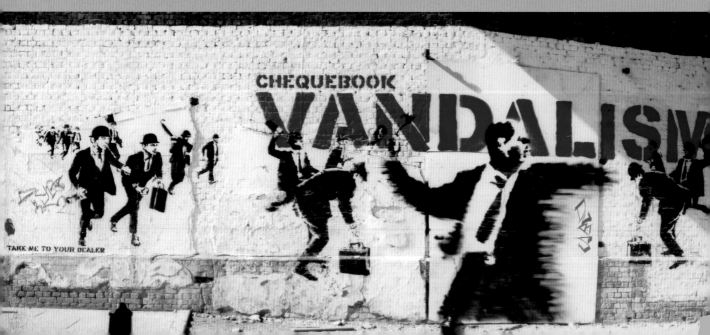

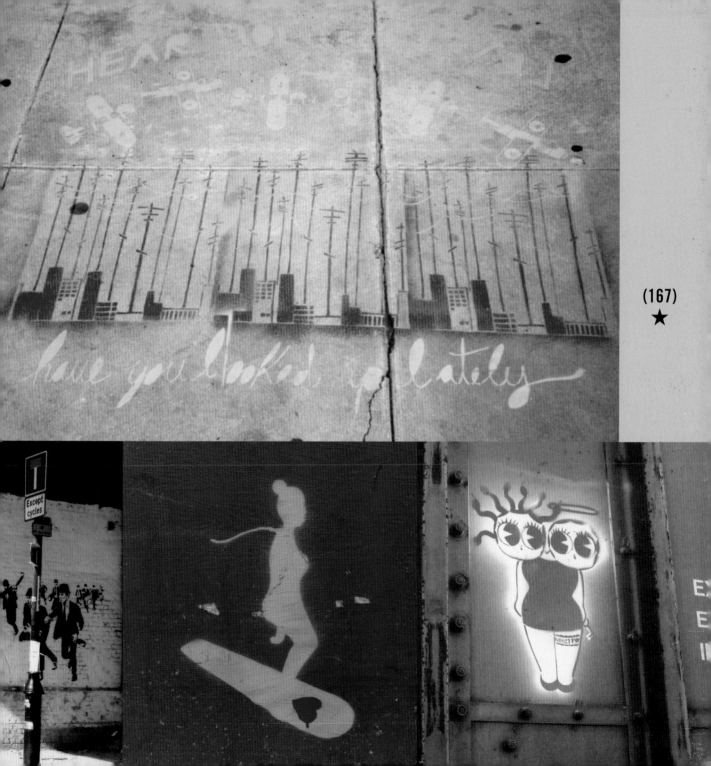

have you looked up lately

(167)
★

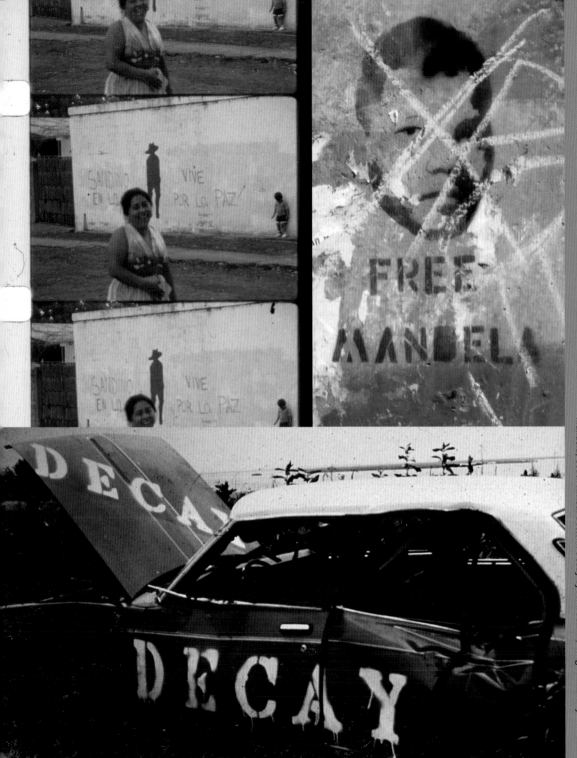

Top left: Film still from "Nicaragua: Hear-Say/See-Here." Top Right: Free Mandela, South Africa. Bottom: Decay by John Fekner, Long Island City NY.

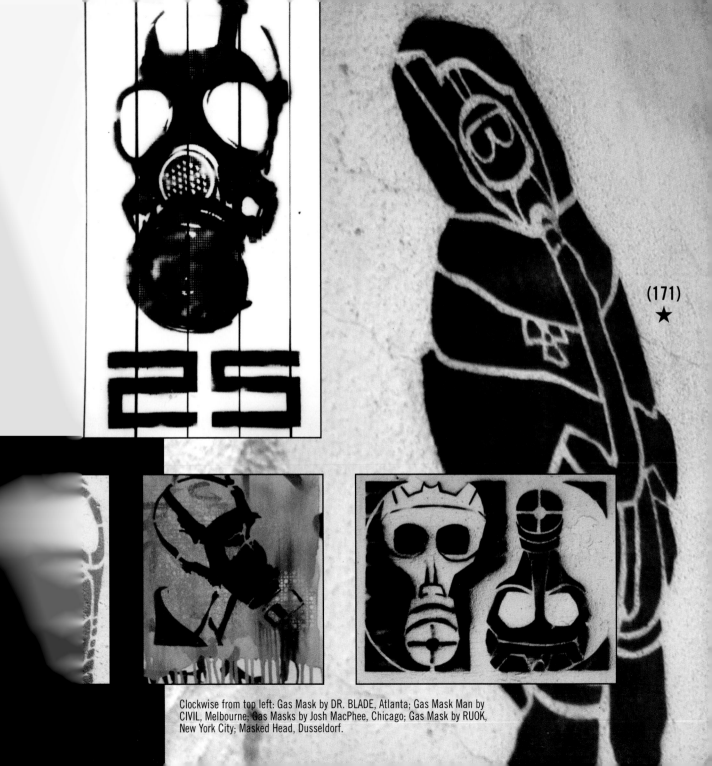

Clockwise from top left: Gas Mask by DR. BLADE, Atlanta; Gas Mask Man by CIVIL, Melbourne; Gas Masks by Josh MacPhee, Chicago; Gas Mask by RUOK, New York City; Masked Head, Dusseldorf.

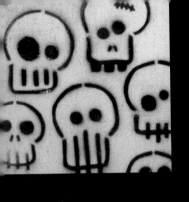

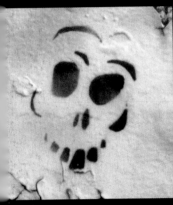
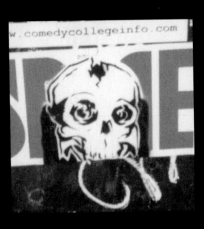
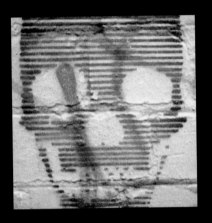
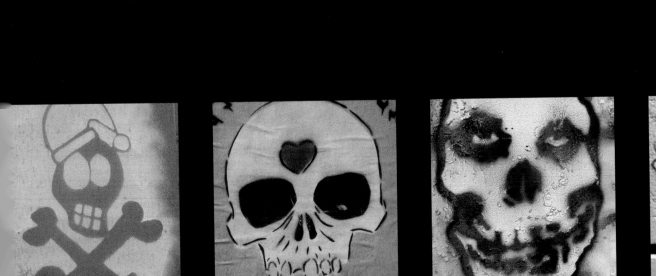

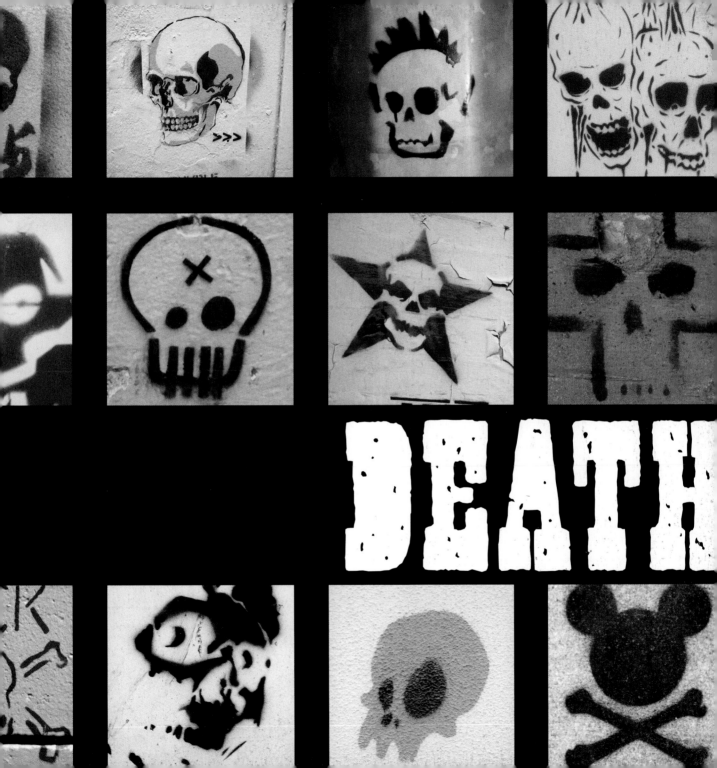

DEATH

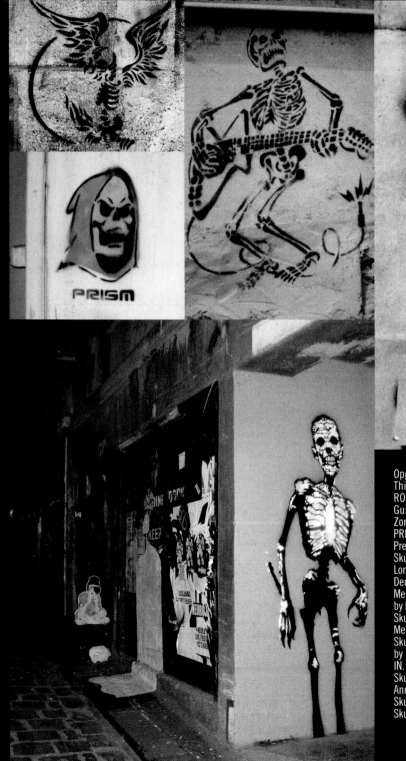

THROUGH THE
DARKNESS THAT
ENVELOPED HIM
HE HEARD ANOTHER
METALLIC CLICK,
AND KNEW THAT
THE CAGE DOOR HAD
CLICKED SHUT AND
NOT
OPEN

PRISM

Opposite: Ghost Writer, San Francisco.
This page, clockwise: Bird Skeleton by RORSCHACH, Philadelphia; Skeleton with Guitar, Bloomington IN; Hanging, Bristol; Zombie by PRISM, Melbourne; Skeletor by PRISM, Melbourne.
Previous two pages, top row left to right: Mini Skulls by Chris Bettig, Los Angeles; Obey Skull, London; Skull by NEPTUNE, San Francisco; Demon Skull by YACK, Lille France; Skull, Melbourne; Spiky Skull, Bloomington IN; Skulls by Lord Hao, Paris. Middle Row: Skull, Chicago; Skull by SEVENIST, Chicago; Skull by Schwipe, Melbourne; Skull by DRA, Bloomington IN; X Skull by Chris Bettig, Los Angeles; Star Skull by DLUX, Melbourne; Cross Skull, Bloomington IN. Bottom Row: Bandana Skull, Melbourne; Skull, San Francisco; Misfits Skull by BAKER, Ann Arbor MI; Suck Skull, Bloomington IN; Skull, Los Angeles; Skull, Melbourne; Mickey Skull by Supersphere, Chicago.

(175)
★

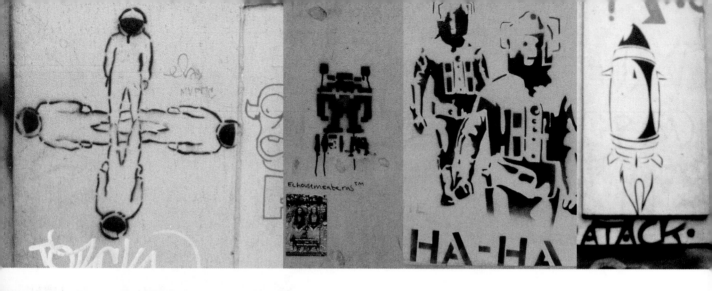

THE FUTURE

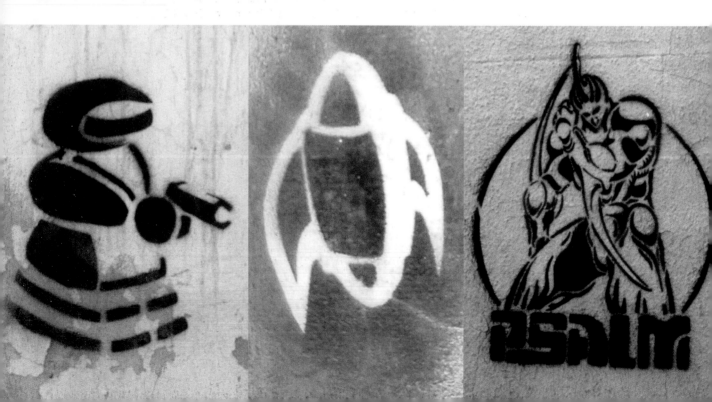

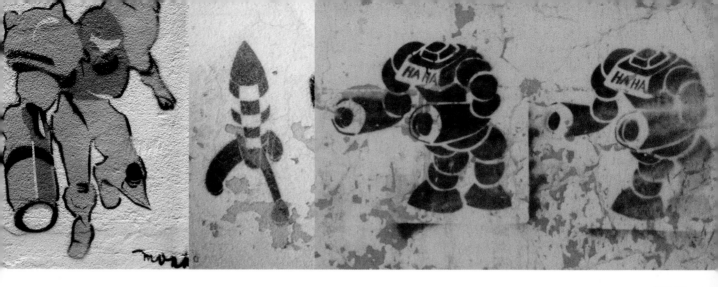

Top row, left to right: Astronauts, San Francisco; Robot, Athens Greece; Monkey Space Men by HA-HA, Melbourne; Rocket by TEMPER, Athens Greece; Anime Robot by MONKEY, Melbourne; Rocket, Melbourne; Robots by HA-HA, Melbourne. Bottom row: Robot, Melbourne; Spaceship, San Francisco; Guyver by PSALM, Melbourne; Robodog by BANKSY, London; Anime Robot by RESIN, Melbourne.

Below left: The Kiss by SIXTEN, Melbourne. Below Right: Kiss, Los Angeles. Opposite page, top row: RB+T, Louisville; Sickboy Loves Sickbrat, Bloomington IN; This Fucking Sucks, Bloomington IN. 2nd row: Gertrude 'n Alice by Corinna, Bloomington IN; Levitating Kiss by BSASTNCL, Buenos Aires; Jill Loves Sarah; San Francisco.

This page, top row left to right: Telescope Boy, Melbourne; Women, Melbourne; Thinker by Ryan Rivadeneyra, Miami; Women with Cat, Melbourne. Second row: Mudflap Girl, Bloomington IN; Boy, Melbourne; Sign Painter by ANT, Vienna Austria; Shadow by Poe Hel, Nashville. Third row: Woman with Skate Baby, Ann Arbor MI; Headphone Girl, New York City; Child with Butterfly by Kristine, New Paltz NY; Couple, Nashville. Fourth row: Boy by VICTIM, Melbourne.

Opposite page, top row left to right: Twins, Melbourne; White Suit by the Zeros, New York City, Inverse Workers by Ally Reeves, Nashville; Pumpkin Suit by NUMSKULL, Sydney. Middle row: Suit with Tie, Melbourne; Christopher & Glen, Melbourne; 50's Suit with Hat by SEVN, Vancouver. Bottom row: Suit by AM, Melbourne; Suits by Essenhaitch, Bristol; Fallen Suit by Toben Windahl, San Francisco; Inverse Suit, Melbourne; Suit by BMC Crew, Milwaukee.

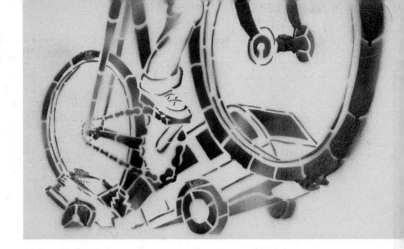

(182)
★

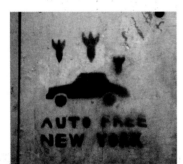

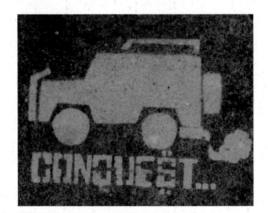

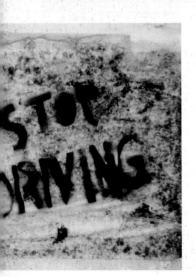

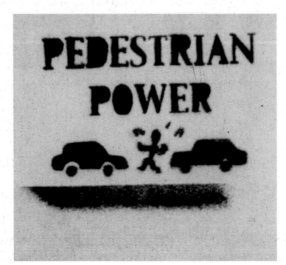

Clockwise from top left: Smart People Ride, Melbourne; Bike Crushing SUV, Bloomington IN; BMX Rider by PSALM, Melbourne; Cult of Biketown, Bloomington IN; Bike, San Francisco; Critical Mass, Pittsburgh; BMXs, Perth Australia; Ride Bikes, Allston MA; Pedestrian Power, London; Stop Driving, Memphis TN; Auto Free New York, New York City; Conquest SUV, San Francisco.

(184) ★

Above: Jamie Thomas by RONE2, Melbourne.
To the left, top to bottom: Honor Skateboards, Arcata CA; Skating Wrestler, San Francisco; Skateboard Here, Philadelphia.

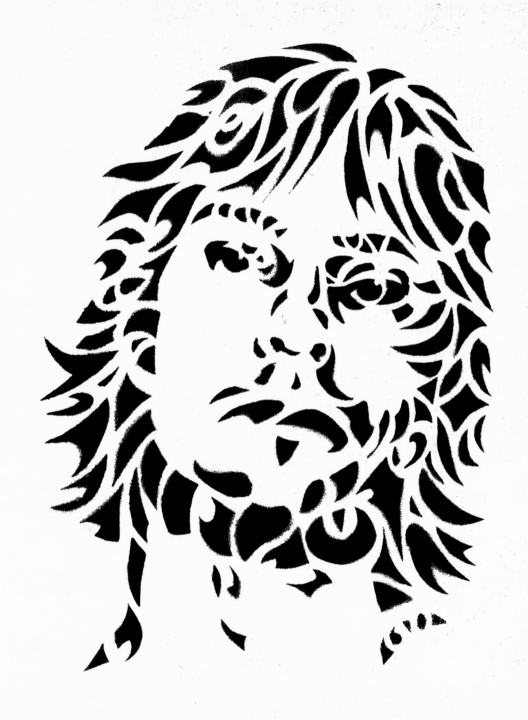

THIS AREA
UNDER VIDEO
SURVEILLANCE

Public Space video taped for your protection

THE GOVERNMENT HAS US ALL ON CAMERA.

Top image: Camera by RONE2, Melbourne. Inset: This Area Under Video Surveillance, New York City. Left: Public Space Video Taped for Your Protection by RSL, San Francisco. Above: The Government Has Us All On Camera, San Francisco.

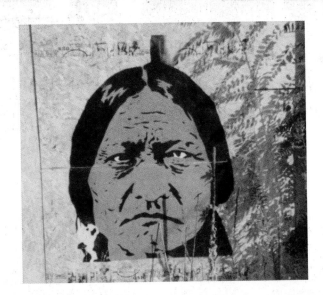

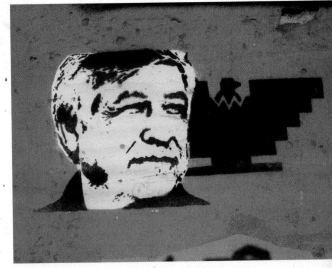

FRIDA
KAHLO

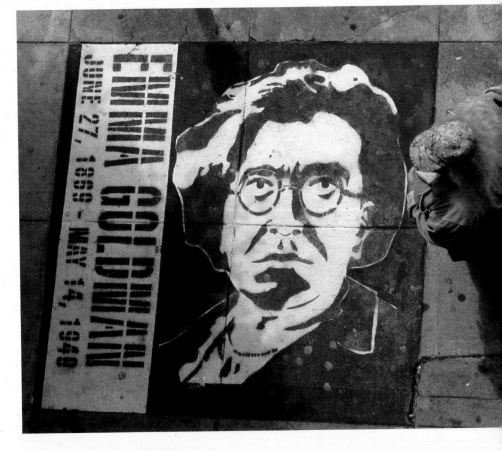

EMMA GOLDMAN
JUNE 27, 1869 - MAY 14, 1940

HEROES

Opposite, clockwise from top left: Sitting Bull by STAIN, Albany NY; Ceasar Chavez by Steve Lambert, San Francisco; Emma Goldman by Claude Moller, San Francisco; Emiliano Zapata by Nico, Los Angeles; Frida Kahlo by Pico Sanchez, San Francisco.
This page: Malcolm X by Claude Moller, San Francisco.

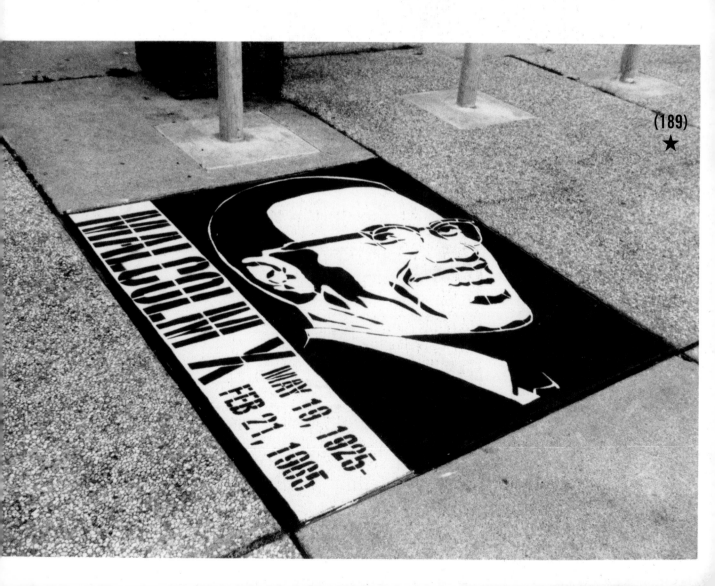

END NOTES

1 Author interview with Anton van Dalen, August 7, 2003.
2 JoAnne Day, *The Complete Book of Stencilcraft* (New York: Dover Publications, Inc., 1987), 9.
3 Norman Laliberté and Alex Mogelon, *The Art of Stencil* (New York: Art Horizons, 1971), 7.
4 Leah Dickerman, Ed., *Building the Collective: Soviet Graphic Design 1917-1937* (New York: Princeton Architectural Press, 1996), 70.
5 Liz McQuiston, *Graphic Agitation* (London: Phaidon Press, 1993),17-18.
6 *The Art of Stencil*, 7.
7 Tristan Manco, *Stencil Graffiti* (New York: Thames & Hudsen, 2002), 9.
8 My discussion of stencils in Nicaragua was informed by an interview with Jeffrey Skoller on September 19, 2003 and by Cabezas (1984) and Sheesley (1991).
9 Sue Williamson, *Resistance Art in South Africa* (New York: St. Martin's Press, 1989), 96-97.
10 Charmaine Picard, "The Art of Urban Recycling: The Artist Collective Suma, 1976-1982." Unpublished thesis paper, and Goldman, Shifra M., *Dimensions of the Americas* (Chicago: University of Chicago Press, 1994), 33-34. Gee Vaucher, *Crass Art and Other Pre Post-Modernist Monsters*. (San Francisco: AK Press, 1999), 28, 40.
11 Rainer Hildebrandt, *The Wall Speaks* (West Berlin: Verlag Haus am Checkpoint Charlie, 1985), 21, 24.
12 Hermann Waldenburg, *The Berlin Wall* (New York: Abbeville Press, 1990), 12-14.
13 Author interview with Mary Patten, July 2003.
14 For further discussion of the interaction between trained artists and graffiti writers in New York, see Schwartzman (1985), p. 10-12.
15 Author interviews with van Dalen, Seth Tobocman (August 8, 2003), and John
16 Fekner (August 9, 2003).
17 Tobocman interview. In addition, see *World War 3 Illustrated* #4, p. 34.
18 Tobocman interview.
19 Barry Blinderman, *David Wojnarowicz: Tongues of Flame* (New York: Distributed Art Publishers, 1990), 118.
20 Tobocman interview. In addition, see Robinson (1990), p. 12.
21 Information about the Baltimore stencil scene can be found in Megan Hamilton's essay "Stenciled on Marble Steps, Woven Into Rows" in Link

Magazine, no. 2, Summer 1997 and Peter Walsh's essay "Mapping Social and Cultural Space: The Ramifications of the Street Stencil." written for the On The Street-Off The Street stencil exhibition and published in the Baltimore Artscape '96 exhibition catalog.
22 Van Dalen interview.
23 Richard Marshall, *Jean-Michel Basquiat* (New York: Harry N. Abrams, Inc., 1992), 236.
24 Fekner interview.
25 Lucy Lippard, *Get the Message?* (New York: E.P. Dutton, 1984), 272.
26 Van Dalen interview.
27 Russell Howze, "Stencil Art: Revolutionary Meme." Unpublished article.
28 *Stencil Graffiti* , p.9.
29 Howze.
30 Eva Sperling Cockcroft, "Collective Work,"p. 196 from Mark O'Brien and Craig Little, eds., *Reimaging America: The Arts of Social Change* (Philadelphia: New Society, 1990).
31 Personal correspondence with Logan Hicks.
32 Personal correspondence with Scout.
33 Ryan Hollon, unpublished article about Argentina and stenciling.
34 Ibid.
35 Jenny Schockemoehl, "Harbinger," unpublished writing.
36 Hollon.
37 Ed Eisenberg's personal documents and notes from the Groundwork Project, available in the REPOHistory Archives, Fales Library, New York University. In addition, personal correspondence with Gregory Sholette.
38 Gregory Sholette, "Dark Matter, Activist Art and the Counter-Public Sphere," available at www.artic.edu/%7Egshole/pages/Writing%20Samples/ DarkMatterTWO.htm
39 Tobocman interview.
40 See BBC, "Artist Throws Anti-Jubilee Party" at http://news.bbc.co.uk/1/hi/ entertainment/arts/2018739.stm and Joe La Placa, "London Calling" at www.artnet.com/magazine/reviews/laplaca/laplaca8-25-03.asp
41 Howze.
42 *Chicago Sun-Times*, Wednesday, April 25th, 2001.
43 Shepard Fairey, "Manifesto," at www.obeygiant.com/articles.html

Publications with images or information on street stencils or the history of stenciling:

Banksy. *Banging Your Head Against a Brick Wall*. London: Weapons of Mass Distraction, 2001.

Banksy. *Cut It Out*. London: Weapons of Mass Distraction, 2004.

Banksy. *Existencilism*. London: Weapons of Mass Distraction, 2002.

Blinderman, Barry, ed. *David Wojnarowicz: Tongues of Flame*. New York: Distributed Art Publishers, 1990.

Burns, Kelly. *I NY*. New York: 4 a.m. Press, 2003.

Cabezas, Omar and Dora Maria Tellez. *La Insurreccion de las Paredes*. Nicaragua: Editorial Nueva Nicaragua-Ediciones Monimbo, 1984.

Fekner, John. *Stencil Projects: Lund & New York 1978-1979*. Sweden: Edition Sellem, 1979.

Folk, Saskia. *Conform*. Victoria Australia: Palgrave MacMillan, 2004

Huber, Joerg. *Paris Graffiti*. New York: Thames & Hudson, 1986.

Hundertmark, Christian. *The Art of Rebellion*. Corte Madera, CA: Gingko Press, 2003.

Indij, Guido. *Hasta La Victoria, Stencil!* Buenos Aires:La Marca Editora, 2004.

Laliberté, Norman and Alex Mogelon. *The Art of Stencil*. New York: Art Horizons, 1971.

Manco, Tristan. *Stencil Graffiti*. New York: Thames & Hudson, 2002.

Maisenbacher, Christoph. *An Die Wand Gersprüht...Schablonengraffiti*. Frankfort: Fischer Boot, 1988.

Metz-Prou, Sybille and Bernhard van Treek. *Pochoir: Die Kunst des Schablonen-Graffiti*. Germany: Schwarzkopf & Schwarzkopf, 2000.

Nuklé Art. *Pochoir a la Une*. Paris: Éditions Parallèles, 1986.

Robinson, David. *Soho Walls: Beyond Graffiti*. Thames & Hudson, New York, 1990.

Schwatzman, Alan. *Street Art*. Garden City, NY: Dial Press, 1985.

Sheesley, Joel C. *Sandino in the Streets*. Bloomington, IN: Indiana University Press, 1991.

Skoller, Jeffrey. "Nicaragua: Hear-Say/See-Here", 1986, 16mm film, color, sound, 64 mins. Dist. by Canyon Cinema Inc., San Francisco, CA.

Smallman, Jake and Carl Nyman. *Stencil Graffiti Capital: Melbourne*. New Jersey: Mark Batty Publisher, 2005.

Tobocman, Seth. *You Don't Have to Fuck People Over to Survive*. San Francisco: Pressure Drop Press, 1990.

Van Dalen, Anton. *Stencil Inventory: Eye Speak, (1980-99)*. Amherst, MA: University of Massachusetts Art Department, 1999.

Waldenburg, Hermann. *The Berlin Wall*. New York: Abbeville Press, 1990.

Williamson, Sue. *Resistance Art in South Africa*. New York: St. Martin's Press, 1989.

Above, top: Assault the Senses by APE7, Sydney.
Middle: Stabbing by KIRO, Volos Greece. Below:
Military Action by WITH/REMOTE, St. Paul MN.
Opposite: Scissors by Ryan Rivadeneyra, Miami.

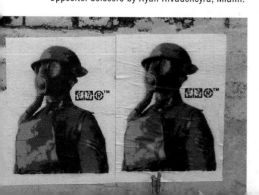

Websites:

Global Stencils:
www.stencilarchive.org
www.stencilrevolution.com
www.visualresistance.org
www.woostercollective.com
www.flickr.com/photos/tags/stencil/

North America:
www.acamonchi.com/stencils/index.html
www.chrisstain.com
www.eyeformation.net
www.mathewcurran.com
www.phoenix.liu.edu/%7Ejfekner/index.html
www.stensoul.com
www.twentyfive.org
www.vinylkillers.com

South America:
www.bsasstencil.com.ar
www.graffitivivo.art.br/
www.smnr.com.ar/foro/portal.php

Australia:
www.psalm.com.au/#
www.james-dodd.com

Europe:
aouw.org
banksy.co.uk
bleklerat.free.fr
www.c6.org/fly
www.cooper.edu/art/lubalin/ambush.html
www.expatrick.com/streetart/
www.fotolog.net/hao1
www.graffiti.org/brighton/stencils/index.html
invisiblemadevisible.co.uk
www.parispochoirs.com/V2/index.html
www.schhh.unmicroclima.com/
www.stencilarea.com

Eastern Europe:
www.2020.ro/RomanianStencilArchive/
www.m-city.org/
www.szablon.art.pl
www.txmx.de/grafix/stencils/

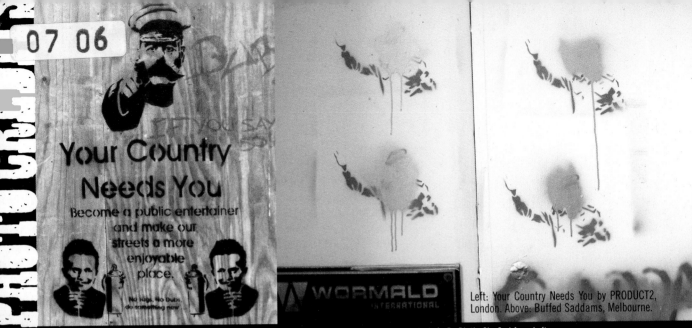

Left: Your Country Needs You by PRODUCT2, London. Above: Buffed Saddams, Melbourne.